Voices for the Land

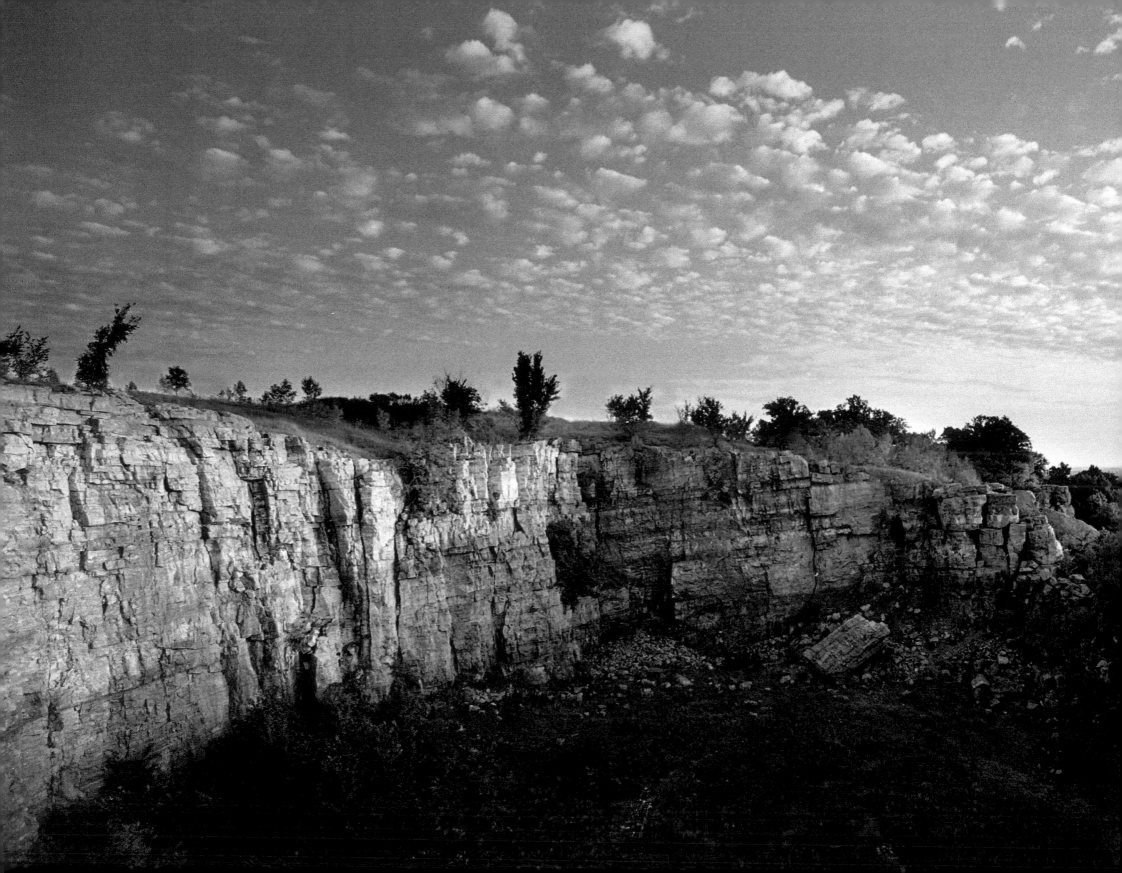

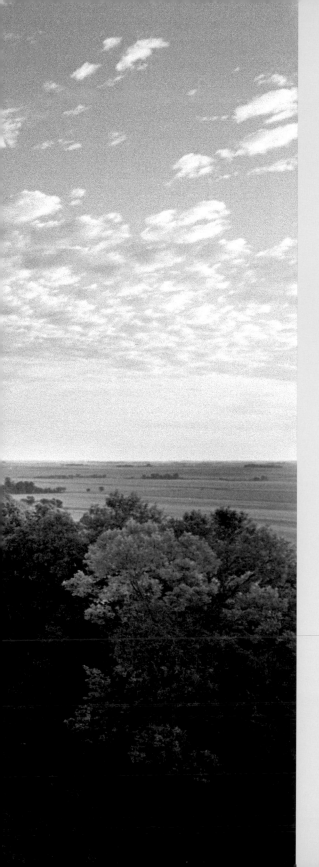

VOICES FOR THE LAND

Minnesotans Write About
the Places They Love

PHOTOGRAPHS *by*
BRIAN PETERSON

Forewords by Paul Gruchow and Jim Brandenburg

Published in cooperation with
1000 Friends of Minnesota

MINNESOTA HISTORICAL SOCIETY PRESS

This book is dedicated to the State of Minnesota, its natural landscapes and its people.

Publication of this book was supported in part by 1000 Friends of Minnesota and by the Elmer L. and Eleanor J. Andersen Publications Endowment Fund of the Minnesota Historical Society.

www.mnhs.org/mhspress

The material in this book is based upon articles submitted in conjunction with the Voices for the Land project, which were published either in the *Star Tribune* (Minneapolis–St. Paul edition) between 1999 and 2001 or in the chapbooks *Voices for the Land* (© 2000) or *Voices for the Land II* (© 2001) published by Milkweed Editions. Brian Peterson is an employee of the Star Tribune, and many of the photographs in this book were first published in the *Star Tribune* (© 2000, 2001). Reprinted with permission. Star Tribune retains certain copyright and syndication rights.

Manufactured in Hong Kong

10 9 8 7 6 5 4 3 2 1

This book is printed on a coated paper manufactured on an acid-free base to ensure its long life.

International Standard Book Number
0-87351-431-9 (cloth)
0-87351-432-7 (paper)

Library of Congress Cataloging-in-Publication Data

Voices for the land : Minnesotans write about the places they love / photographs by Brian Peterson ; forewords by Paul Gruchow and Jim Brandenburg.
 p. cm.
Produced by the Minnesota Historical Society.
Includes index.
ISBN 0-87351-431-9 (cloth : alk. paper)
ISBN 0-87351-432-7 (pbk : alk. paper)
 1. Minnesota—Description and travel—Anecdotes.
 2. Minnesota—History, Local—Anecdotes.
 3. Natural areas—Minnesota—Anecdotes.
 4. Minnesota—Biography—Anecdotes.
 I. Peterson, Brian, 1959–
 II. Minnesota Historical Society.

F610.V64 2002
977.6—dc21 2002021949

Voices for the Land was designed and set in type by Will Powers at the Minnesota Historical Society Press, St. Paul. The jacket and cover were designed by Percolator, Minneapolis, and the book was printed by Kings Time Printing Press, Ltd., Hong Kong.

Voices for the Land

Foreword

A PLACE IS NOT A THING; IT IS A RELATIONSHIP. A location becomes a place only in the context of time, of history. Beauty has little to do with it, or rarity, or purity. It is quite as easy to love an urban alley, or an old swamp, or an abandoned lot, or a dirt road as it is to love the Mississippi, or the North Shore, or the Boundary Waters. Beauty in nature is like beauty among human beings: it lies in the eyes of its beholders. So it is to be expected that the places here described so affectionately are not, in the main, those one would first think of as the best Minnesota has to offer, nor those one would think first to try to save. But we *should* think of them and try to save them. Ordinary places are as necessary to a good community as are ordinary people. Let us celebrate them, places and people both, every one.

PAUL GRUCHOW

Foreword

TO A PHOTOGRAPHER, coming upon rare and interesting light is like finding a new and delightful friendship. Unfortunately, the relationship with this newfound friend is always elusive and much too fleeting—surely, one thinks, never to be seen again?

I met Brian Peterson in the midst of some of the most unusual light I've seen. While I was working at my remote bush camp at the edge of the Boundary Waters, he came with a writer to report on a book of mine that was recently published. As we talked of special places and how important they are to us, we were overtaken with a near-total solar eclipse. A warming, bright spring day was slowly turning darker and darker, producing a cool and eerie landscape. As the moon slid in front of the sun, we turned our attention from my project toward the bigger story unfolding all around us.

Instinctively, we tried to capture this rare spectacle with our cameras. But like most of my attempts to record something special to me, our efforts were to no avail and I have no lasting image from that day—only a wonderful memory. This is the usual result for a working photographer. Most subjects and events never yield that memorable photograph we all seek.

Strong photographs, elusive as they are, when set with stories written with feeling like those collected here, have the power to change the way we think about the world and ourselves. Professional photographers may debate why it is that black-and-white images are often more evocative and penetrating than those made in color, but their effect is undeniable. Peterson has produced some of the finest photography ever made with Minnesota subjects, and this collection displays it at his typical best, an artful moment wrapped around a pertinent subject.

The writers' feelings for their subjects clearly come through in this book. The challenge, in my experience, lies in interpreting these precious stories with imagery that matches and complements the writer's personal home advantage. In the almost-lost tradition of *Life* magazine, where the black-and-white still image became the standard in penetrating reportage, we can see here again the classic photographic essay.

The land, and our feelings toward it, are topics I increasingly hunger to see more of in the popular press. The "big" stories often crowd out the quiet narratives like *Voices for the Land*. Dare I say that I even feel more *trust* in the work of someone like Brian Peterson, who clearly has an affinity for the land and can capture its power and spirit? This talent is often missing from other photojournalists who have the ability to portray the power of personalities in portraiture, like Brian's image on page 95. This fine portrait of Bill Holm is revealing and intimate, as though we had just spent the day on the prairie with him ourselves.

This quiet land can stretch into horizons in our minds when given an eloquent voice by translators who hold passions and gifts such as we see here. This is a book full of new—but lasting—friends.

JIM BRANDENBURG

Acknowledgments

We extend our deepest appreciation to Elly Sturgis for her assistance in making this book possible. We thank Brian Peterson for his wonderful photographs and enduring patience during every stage of this project. Special thanks also go to Paul Gruchow and Jim Brandenburg for their unique insight and contributions to this book. We owe much gratitude to Wendy Bennett, Jeanne Campbell, Gayle Peterson, and Hollis Stauber for the original Voices vision. Sid Farrar and Milkweed Editions were invaluable help with the first *Voices for the Land* chapbooks. Thanks are also due Betsy Bowen, Wayne Goeken, Jan Zita Grover, Don Hickman, Marybeth Lorbiecki, Molly MacGregor, Debbie Meister, and Eric Ringham for their participation with the chapbooks. We also want to recognize the Bush Foundation for its continued support of the Voices for the Land project. And we want to acknowledge the Minnesota Historical Society Press and their part in bringing this book to fruition.

1000 FRIENDS OF MINNESOTA

I would like to thank the Star Tribune for its willingness to commit the time and space to the Voices for the Land project. A special thanks to Steve Rice, Rhonda Prast, Randy Miranda, Susie Hopper, Kathe Connair, Tom Wallace, Vickie Kettlewell, Glenn Stubbe, Ellen Lorentzson, Deb Pastner, Dave Denney, Peter Koeleman, and the rest of the Star Tribune photo staff who put up with my absence while I was working on this project. Thanks to Regina McCombs, Jaime Chismar, and Dave Braunger of the Star Tribune online staff—their dedication and commitment to perfection helped create a website that will carry the Voices for the Land project beyond the borders of Minnesota. I would like to thank Bill Droessler and Lee Ronning of 1000 Friends of Minnesota and Greg Britton of the Minnesota Historical Society Press for their belief in this book and their persistence in seeing it through to publication. I also thank Jim Brandenburg for his kind words and inspiration. He is one of the most gifted and dedicated photographers in the world.

I would like to thank my wife, Lori, and daughters, Sarah, Alyssa, and Natalie, for their willingness to put up with my passion for photography; without them I would not be. Lastly, I thank my grandfather, Emil Dreher, who taught me to appreciate a place that is so quiet you can hear your thoughts, so dark you can touch the stars, and so peaceful that it energizes the soul.

BRIAN PETERSON

Introduction

IT STARTED AS A FAINT, LOW HUMMING, and in the remote boreal forest of central Saint Louis County, machinery was an unfamiliar sound. We knew it was coming: we had received notice from the land department in 1998 that the timber had been sold and the loggers would begin their work sometime in the next three years. It was now late 2001 and the deadline for cutting was near; we were hoping they had forgotten "our woods" and that the time would expire. But then reality pierced the silence of that clear and cold November morning. The trees were coming down, and it was hard to believe. We didn't own this land—it belonged to the state—but I guess we always felt the ugliness of the landscape—no lakes, panoramic views, or rushing waterfalls—would save "our woods" from development. And the trees were just a scraggly collection of poplar, birch, and a few deformed white pines that had been passed over when the region was last logged in the late 1800s. What logger would want these trees?

From the earliest years of my childhood, I can recall this place, known simply as "the woods." Unspectacular in its beauty, it was filled with childhood memories of star-studded skies, wolf howls that would break the silence of the night, and walks with my grandfather. The woods seemed so large to a child, and getting lost was an ever-present fear. We would walk for hours, following the many trails that kept us on familiar ground, stopping to rest on the silhouette of an old white-pine stump, a ghost of the previous forests now covered with moss. A few of the stumps were four to five feet in diameter. We would lie across them and lament that not one had been left standing as a witness to the past. And now, one hundred years later, the woods are coming down again, trees this time mere dwarfs of their ancestors. And as logging roads pierce this once-wild land, the motors of the ATVs and snowmobiles that are sure to follow will break the silence. Maybe it's a selfish thought, wanting to have this land to enjoy without intrusion, but I believe that we are losing a valuable asset every time we tame another acre of wild land.

As we move into the twenty-first century, Minnesota is the fastest growing state in the Midwest, and the landscape around us is changing dramatically. From 1982 to 1997 the Twin Cities experienced a 25 percent increase in population but at the same time lost 61 percent of its undeveloped land. As more and more people make Minnesota their home, often attracted by the natural beauty and open spaces that still exist, we are rapidly losing the very land that appealed to us in the first place.

The idea for Voices for the Land began as a conversation among friends: five women sitting around a kitchen table, discussing their frustration with the ever-changing landscape around them. Wendy Bennett, Jeanne Campbell, Gayle Peterson, Hollis Stauber, and Elly Sturgis wanted to amplify the voices of ordinary citizens who were watching helplessly as their favorite places were disappearing. What came of that first meeting in the summer of 1996 was a call for Minnesotans to write a short essay about the land they love. More than 1,500 Minnesotans responded, and fifty-two of the best essays are included in this book.

1000 Friends of Minnesota adopted the Voices for the Land project in 1999, seeking to translate the concerns expressed in these essays into work in communities throughout Minnesota—work that increases people's knowledge of and involvement in land-use decisions locally, regionally, and statewide. Local events brought together hundreds of people to share the joy, hope, and concern of the essayists. There are few things more powerful than citizens speaking from their hearts and sharing their visions for the communities we want our children to inherit and enjoy.

I became aware of the Voices for the Land project in the spring of 2000 after Milkweed Editions published a small chapbook of the twenty-five original winning essays. I immediately felt connected to the concern that threads its way through many of the pieces. I wanted to translate the author's words into photographs before these places, so beautifully described, dissolved into the developed landscape. For one year I traveled more than 17,000 miles throughout the state, with camera and tape recorder in hand, producing a weekly "Voices for the Land" feature for the Sunday *Star Tribune*. (You can hear all of the authors in this book read their essays at http://www.startribune.com/voices.)

Hoping to experience firsthand the magic that inspired them to write, I met each author at the scene of the essay, arranging my visits to coincide with the season and the weather reflected in the piece. My challenge was to translate their words into photographs that would capture the heart of their essays. It was a thrill to meet so many gifted writers, some familiar, others unpublished before this book. It was a pleasure to hike with Howard Schaap to the edge of Buffalo Ridge before dawn on a cool fall morning and watch the sun rise over the southwestern Minnesota prairie; to scale the icy banks of the Pigeon River in northeastern Minnesota with Joanne Hart and witness spring break-up at the high falls;

to sit on a south Minneapolis back porch with Margaret Miles and watch the "street-tough" birds that visit her backyard feeders; to relive the camping memories of twelve-year-old Thuy Nguyen on the banks of the Mississippi River in St. Paul; to walk with Jeri Niedenfuer on the dirt roads of the Cuyuna Iron Range and seek "balm for the urban soul: nature left alone."

The "woods" that I learned to love as a child are gone now, and I feel a deep sense of loss as I look out over the clear-cut. On a recent visit with my youngest daughter, Natalie, we sat on a stump and looked out at the barren horizon. This time, the few remaining white pines stand as lone monuments to the past. Maybe at some future date when my daughters take their grandchildren here, they will sit on one of these stumps and gaze in awe at the grandeur of the pines that were spared.

The land speaks to us in silence. We must listen, and then speak out about our special places and find ways to keep those places from being consumed by development. We must be the voices for the land. I hope this collection of essays and photographs will stand as both a testament to the past and an inspiration for the future.

BRIAN PETERSON

Voices for the Land

Winter

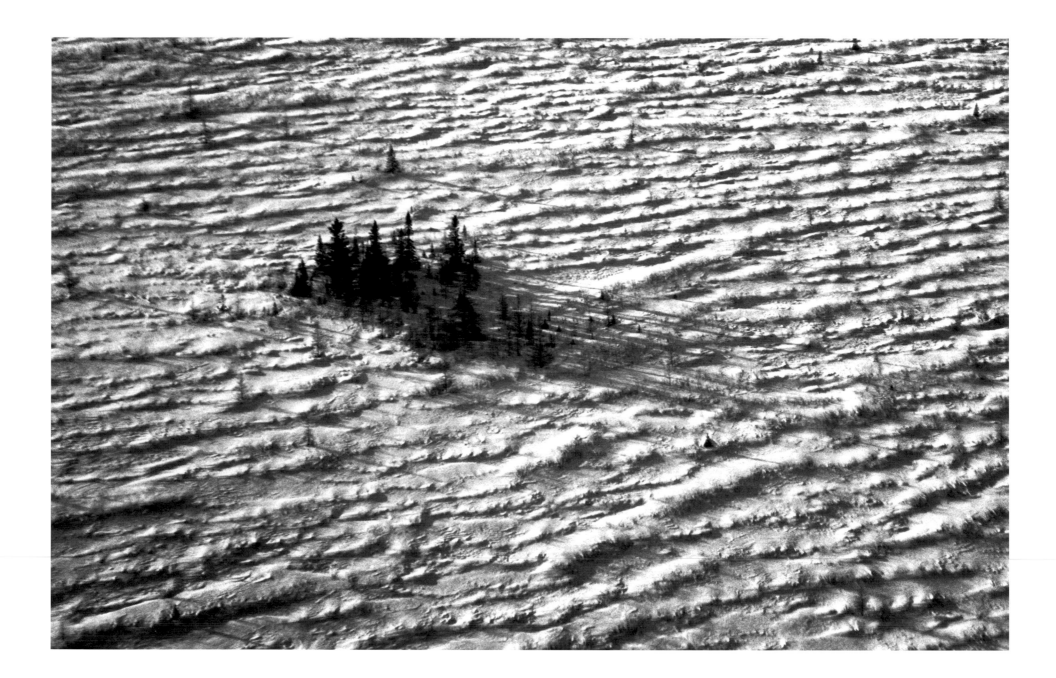

The Cathedral
MICHAEL FORBES
Bemidji

MICHAEL FORBES
draws inspiration for his essays and poems from the forests surrounding his home near the Chippewa National Forest. He believes that too many people are disconnected from the natural world around them and that this distance negatively impacts our relationships with each other and our finite world. Through his writings he hopes to communicate to his readers the joy and wonder he finds in the wild and make them aware of their place in the natural world. He was influenced at an early age by the works of Sigurd Olson. Michael's writing has appeared in the Minneapolis *Star Tribune*, *Community Connections*, *The Talking Stick*, and *The Touchstone* and has been recorded for radio broadcast.

MY SNOWSHOES SWISH SOFTLY ON THE UNMARKED SNOW, the bindings creaking in time as I leave the road behind, weaving my way through the woods on an old logging trail. If I time it right, I should be there just as the sun is setting. It is still warm enough that when I brush against the young balsam firs lining the trail their heady fragrance washes over me like incense. I know I have arrived when the space above me opens under a filigreed dome, formed by the crowns of red pines and crinkly-barked jack pines joining together far overhead. Golden streamers thread between the trunks, leaving diamonds dancing on the snow. Blue shadows fill in the spaces the sunlight leaves behind.

I stand silently in a small opening between some young balsams. High above me, treetops sway gently in the last breeze of the day, but at ground level the air is still. My breath hangs in warm clouds above my head as I breathe slowly in and out, in and out. The rapidly cooling air seems to go right to my belly, as if it is food that can fill me and quiet the hunger deep inside.

This is my cathedral, a space where living, breathing columns greater than anything made by the hand of man infuse me with the spirit of peace. When I first entered here and felt that healing power, I knew I had found a special place.

Pinching a small piece from the tip of a balsam branch, I rub it between my palms before burying my nose in the bowl I make of my hands and inhaling deeply, drawing the resinous incense into my lungs.

Soon the golden streamers are gone, drawn below the horizon with the setting sun. Shadows grow out of the snow, swallowing the diamonds as they feed the darkness. The trees go black and sunlight is a memory beyond the branches overhead. In the dark it would be easy to let worry creep in on my peaceful mood; worry that my silence about this holy place will not protect it from others who might see it only as a material resource. Tucked away on county land above a dense cedar swamp, the cathedral has been untouched since the first loggers passed it by. I suppose that someday all that will remain will be stumps, and memories of a magnificence that is hard to find.

Leaving that thought behind, I turn in the purple twilight and retrace my steps on the packed snowshoe trail. When I turn to look back, my trail disappears in the darkness, but a light stays with me.

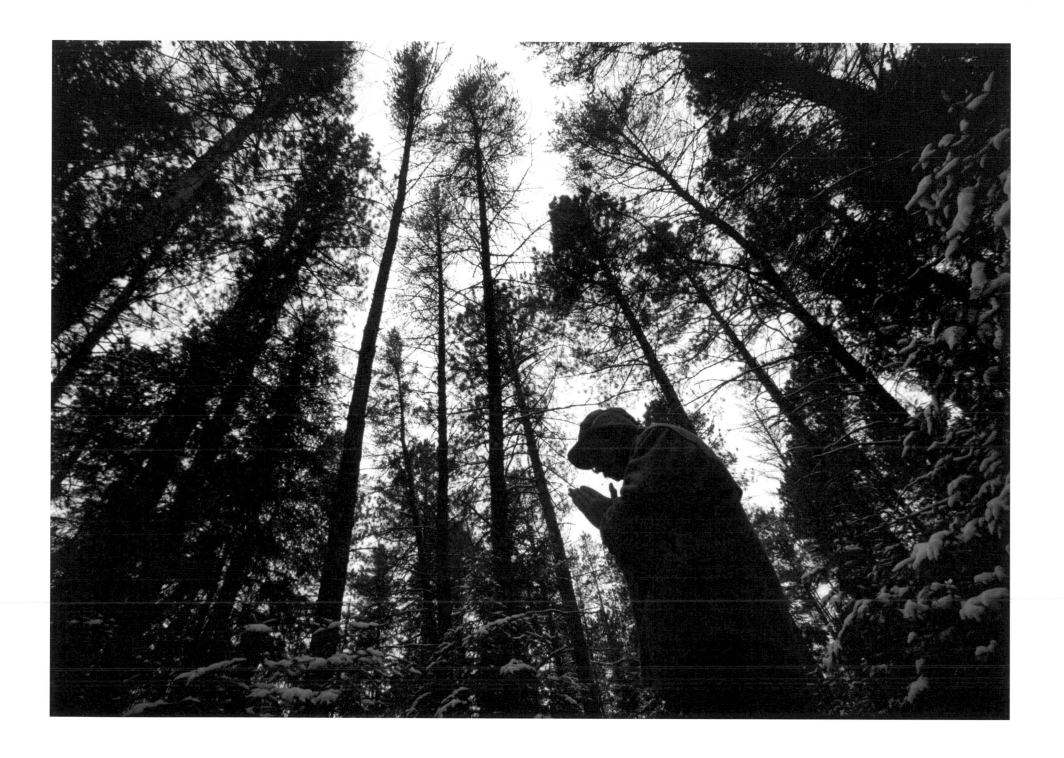

Circles and Mounds

TOM PATTERSON

St. Paul

TOM PATTERSON
is a student conduct liaison for
Bloomington Schools Transporta-
tion. He has also served as direc-
tor of the Minnesota News Coun-
cil, as editor of *NSP News* and the
University of Minnesota's *Medical
Bulletin,* as director of advertising
and public relations for Inter-
national Dairy Queen, and as a
reporter for the Albert Lea *Daily
Tribune.* He learned to love the
land on family trips to Hibbing,
where his great-aunt Tibby taught
him to find wild berries and to
swim in ice-cold Side Lake.

A MURDER HAS CAST A PALL OVER a beautiful, sacred, ancient historical place. All places are ancient and historical if only we can subtract the marks of the present and the recent past. Mounds Park in St. Paul makes it possible for me to ignore, or at least blur, the present and feel my connection to my ancestors.

Mounds Park sleeps in churchlike quiet at the top of the city of St. Paul. As I look to the west, I can see the Cathedral of St. Paul and the state capitol, each on similar high points overlooking the Mississippi River Valley. Streets, cars, buildings, and lights easily are erased in my mind to reveal lush, open, green slopes or an unmarked snow-covered landscape punctuated by the American Indian burial mounds in the forefront of my panorama.

The old bones within these mounds cannot connect me to my Oneida ancestor (yes, singular) in any real way, but they are American Indian and I have long sought to live and feel my Indian connection.

I visit Mounds Park often, at high times and low times in my life, and always on my birthday, when I smoke a sacred pipe to the circle of my existence. The time for that birthday visit is soon, in this dead of winter. I worry that Mounds Park's serene silence has been forever shattered by a terrible, tragic, bellowing gunshot.

I did not know Xia Vang until her circle came loudly around to death at the precise place I go to celebrate my life. She entered my circle on November 25, 2000, and her name entered my prayers from that day until I no longer live to speak it.

I will try to bring a personal peace to this quiet, spiritual place. I will try to mend the circle. I will try to mend it with my pipe.

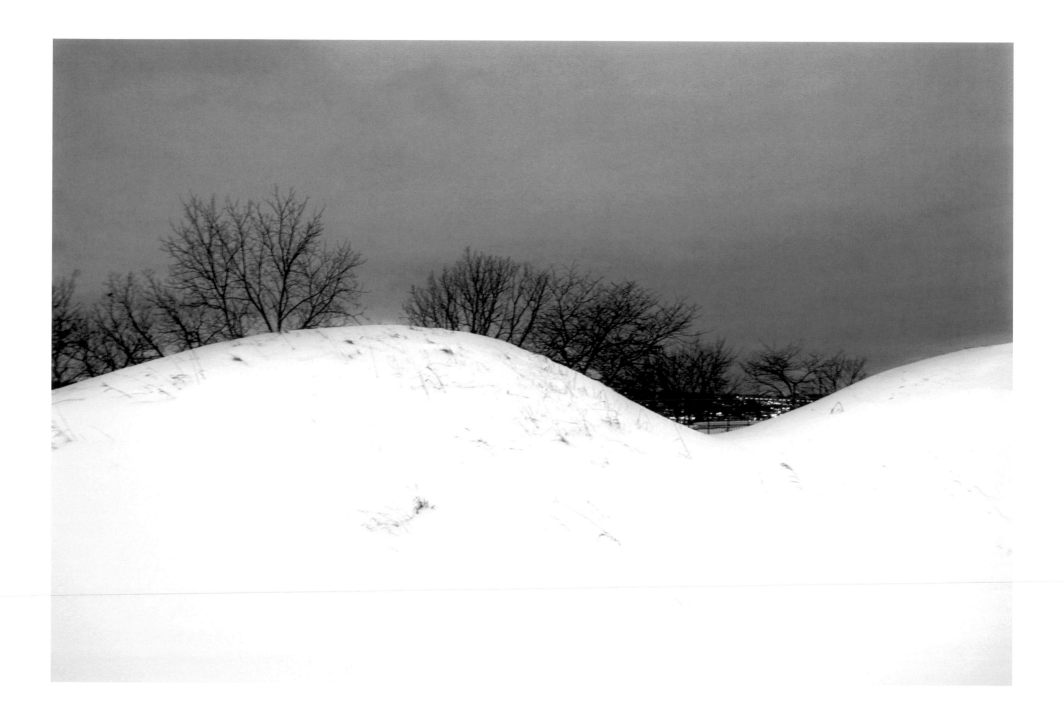

A Place in the City
YUJUNG HU

St. Paul

YUJUNG HU
grew up in Taiwan's densely populated
capital, Taipei, where she learned the
art of savoring one's own small space.
Near her family apartment, on the out-
skirts of Taipei, a hilltop Buddhist temple
surrounded by mature trees changed her
perception about nature. At the temple
square, people practicing Tai-Chi,
Chinese chess players meditating their
next moves, and monks chanting from a
distance were as much a part of nature
as the lush hills. In 1993 she came to the
United States for a two-year study pro-
gram that turned into a much longer
stay. Although she had developed a
career writing in her native tongue of
Chinese, she has begun to speak, write,
think, and even dream in English.

LAST SUMMER WE BOUGHT OUR FIRST HOUSE. My husband and I each wrote a letter back home to distant continents to tell our families about the house, the land, and the surroundings. For my husband's family, the land under the house is more important than the house itself. Houses come and go, but the land is always there.

Our house is on a tiny parcel of land on Chatsworth Street in St. Paul, but it is big enough for an immigrant family to make a home and to grow roots. It is our place in the city. Official documents describe the land clinically as Lot 5, Block 1, Strand Addition, but to us, our home is alive. There is always the hustle and bustle of trains, buses, and cars. Sometimes it is noisy, but we were surprised by how quickly we got used to it. The house is not just a number on the street or a real estate value on the market. It seems to have its own voice.

In the summer the sidewalk is busy with people passing by on their way to Como Park. The jogging mother with a stroller, the old guy with his baseball cap, the running pony-tailed young man, a son and ailing mother, and a man pushing his wife's wheelchair are some of the regulars. I grow familiar with them as I observe them unobserved.

In winter the street is much more quiet. Last winter I was expecting our first child. I sat in the den, which faces our back yard, and imagined how my child will play there, his laughter filling the air as he grows up in this land. This winter I often sit by the dining room window, watching the street as I drink a cup of hot cocoa and my baby takes a nap in his crib. I watch the regulars walk by. They seem to become part of the house. I admire their commitment to health and exercise despite the cold weather. I say a silent hello to them although they don't know me at all. I am always happy that my freshly shoveled sidewalk gives them a safe passage.

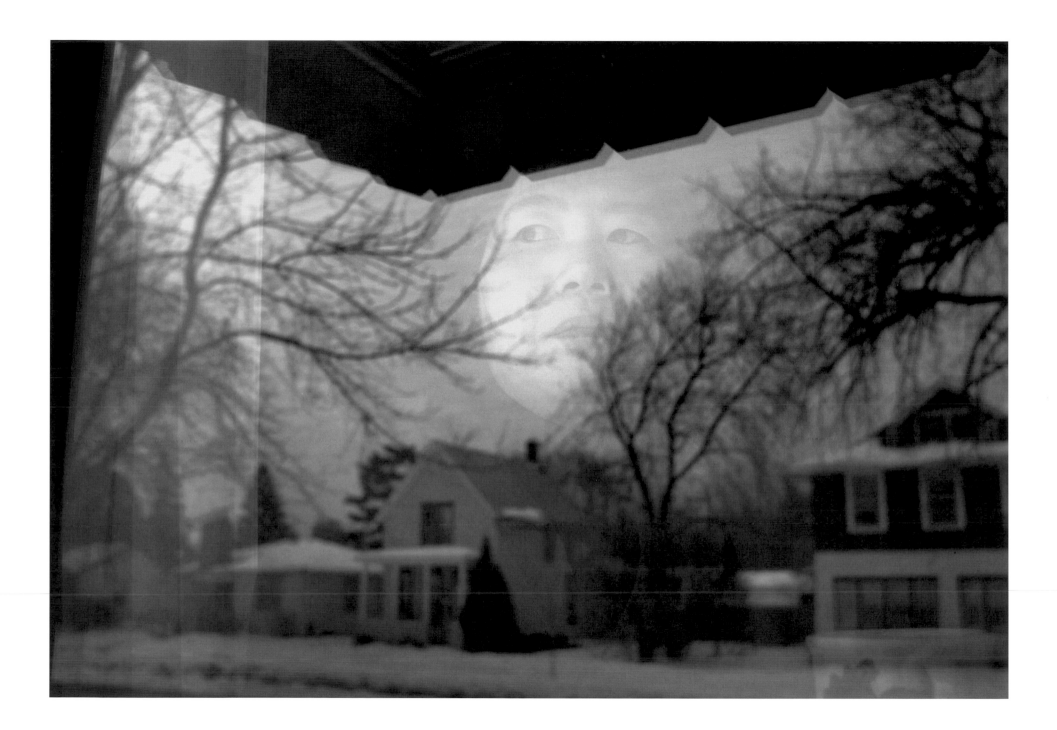

Trespass
ELIZABETH WEIR
Medina

ELIZABETH WEIR
grew up in England and learned
to love the natural world from
her father. She now lives in
Medina and is the theater
reporter for *Skyway News* and
Pulse of the Twin Cities.
Her poems and essays have
appeared in the *Minnesota
Poetry Calendar 2000, Sidewalks,*
and *ArtWord Quarterly.*

I SIT ON A SAWN OAK STUMP in the winter quiet of the Big Woods and listen. Crystalline snow, grit hard, hisses as it strikes the paper-dry leaves of ironwood trees. Beyond the woods, a metallic river of sound flows along County Road 6 and, high overhead, an airplane mumbles.

No other sounds.

It is cold. Very cold. But I am unwilling to leave these ancient trees, fastened in winter. Snow bastes their rough trunks white on their north-facing sides, and the brown leaves of the ironwoods glow chestnut-red against so much whiteness.

All is still. To my left a narrow ironwood has had its young skin ripped to shreds by a buck scraping the velvet from the prongs of his antlers. It looks too damaged to survive. A red squirrel, high in a great maple ahead of me, chatters like a sewing machine. Then he falls silent.

I sit, still as a tree.

Snow granules gather in my lap. My toes ache with brittle cold. I glance toward my boots and see the snow hump close to my right foot. Again it moves. And again. I have caught a deer mouse in the act of tunneling an owl-proof highway beneath the concealing canopy of snow.

Somewhere behind me, a pileated woodpecker bells an abrupt alarm, and a barred owl alights on a slender branch twenty feet from my face. It rides the dipping branch and sees me. It is as startled by my presence as I am by its. For a moment its pond-brown eyes lock on mine. Flustered, it flings upward and lands beside the red squirrel. The squirrel bursts into staccato curses, pelts down the snowy trunk, loses its footing and plummets into deep snow. The owl spreads silent wings and threads an escape through the trees. The squirrel bolts into a crevice in a log, still cursing. From the direction the owl has flown, startled crows erupt in a cacophony of aggression.

I rise. I have caused enough mayhem for one day. Without thinking, I trample the mouse tunnel.

I retrace my snow-softened footprints and, as I walk, the squirrel quiets. The noise of the crows subsides. The woods slip into silence once more, except for the hissing snow.

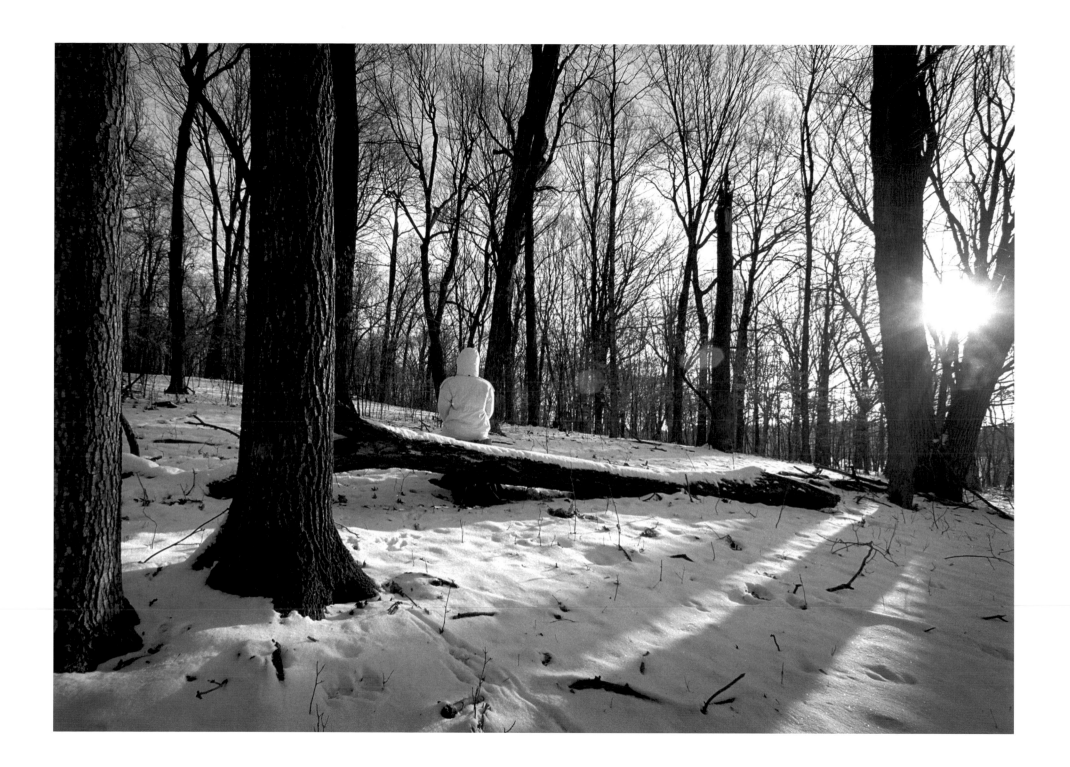

Sauna Moments

JUDY HENDERSON

Becker County

JUDY HENDERSON
traces her life experience of the
natural world to the landscape of the
family farm. The sugar maple woods,
the cow paths, the back road, the
garden, and the fields framed her
childhood playground. The layers of
memory forged on the farm land-
scape yield connective discoveries in
her writing. She has compiled two
history books for family reunions
and, with her nephew, edited and
published *o finland*, a collection of
pieces by Finnish American writers.
Judy's most cherished achievement
is the completion of a bachelor's
degree from Metropolitan State
University, a high school dream
fulfilled in 1997 at age fifty-three.

THERE IS A WINTER MOON TONIGHT, a cold white light shadowing snow. Right now, I'd like to be at the farm. I'd be standing on the outside sauna deck, cooling my hot, steaming skin in the winter light. Finnish-speaking parents left us the land we call the North Slopes. Our great-grandparents were born in the Finnish old country, where land was wealth and sauna is who we are. For ten years, six of us siblings have been writing a monthly check to pay the taxes, fuel oil, electricity, and phone.

This is the sixty-year-old subsistence farm where the family milked cows, made hay, picked berries, planted potatoes, made pickles, hauled wood, hunted deer for venison and where we grew up. "They don't grow land anymore," says one sibling. So we are in the process of figuring out how to pass on our parents' 160-acre farm in Becker County.

The land is swamp, pond, former cultivated fields, sugar maple trees, poplar-covered deer habitat with a small farmhouse that can sleep twelve during a November deer hunt.

And one Finnish sauna. The land is worth what a realtor says it's worth, but our hearts hold the true value. The land carries our memories—of deer stands, of walks on 1940s sheep paths, of raspberry patches and wild plums, of daily walks to the school bus. Not all the memories are sweet: many are bitter, but in the passage of time bitterness fades. Keeping the farm is work: painting, repairs, lawn mowing, wood cutting, sauna-water hauling, and the check written out each month. Owning land with siblings has not been without difficulties, but we search for a compromise path through the familial forest.

A sauna taken on a cold winter night like this, naked as you were born, steaming outside to cool down, feet cold on the walkway boards, black ink sky, cool light of the moon, shadows of the spruce—the worth of the land is diamond-carat priceless.

We'll pass this land on to the descendents of our Finnish American parents. Someday they will pay the monthly fee. Winter moonlight will reflect their sauna moments.

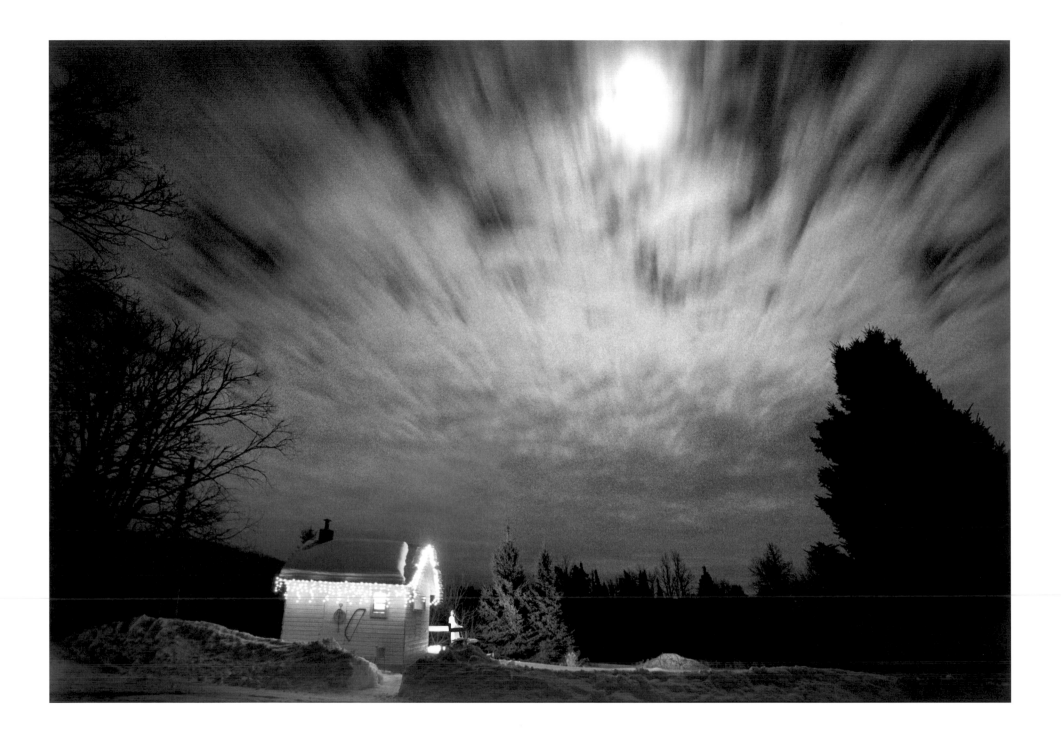

Ice Magic
MOLLY DWORSKY
Minnetonka

MOLLY DWORSKY
wrote this essay as an eighth grader
at Hopkins Junior High. She com-
pares her attitude toward nature to
her attitude toward boys: "When I
was a kid, trees and boys were just
. . . there. When I hit adolescence,
I finally saw why everyone made
such a fuss over the changing
of the leaves."

NORMALLY THE POND ACROSS THE STREET is just a pond across the street. In winter, it turns into our neighborhood's ice-skating rink.

Skating is the only sport I do in winter, and it seems like the easiest thing I do. I took a few lessons and—surprise!—I'm no Tara Lapinski. However, I have one thing going for me: I love it.

Luckily, a hockey coach lives down the road from our house. When the ice is thick enough to walk on, I sit back, relax, and wait for his boys to finish shoveling. Then it's my time on the ice. My time is when everything is quiet. My time is when the only light is given off by the moon and the stars.

After I've got enough layers of clothing on to play strip poker until I'm fifty, I walk the 5,000 stairs from my door to the ice.

When I reach the rink, I'm sweating, and the workout hasn't yet begun. More often than not, I'll make my grand entrance and fall flat on my face. Ninety-five percent of the time it's because the guards are still on my skates. I'll wobble to the middle of the pond and start with my best twirl. (This usually consists of baby steps in a circle.) Then I do a grand finale the critics would have to give "two thumbs up." After that, I get lost in my own world, doing spins and twists that the skating instructors haven't even thought of yet. Sometimes I'll fall, but with such style, you'd have to wonder if I meant to do it. Hour after hour, I dance on the ice.

It feels my presence, and we work together, creating our own special world.

After a while, it's time to come in. I pick up the clothes scattered about the ice and trudge up the steps. The moon follows me, pleading with me to stay. I look back and smile. I'll be back.

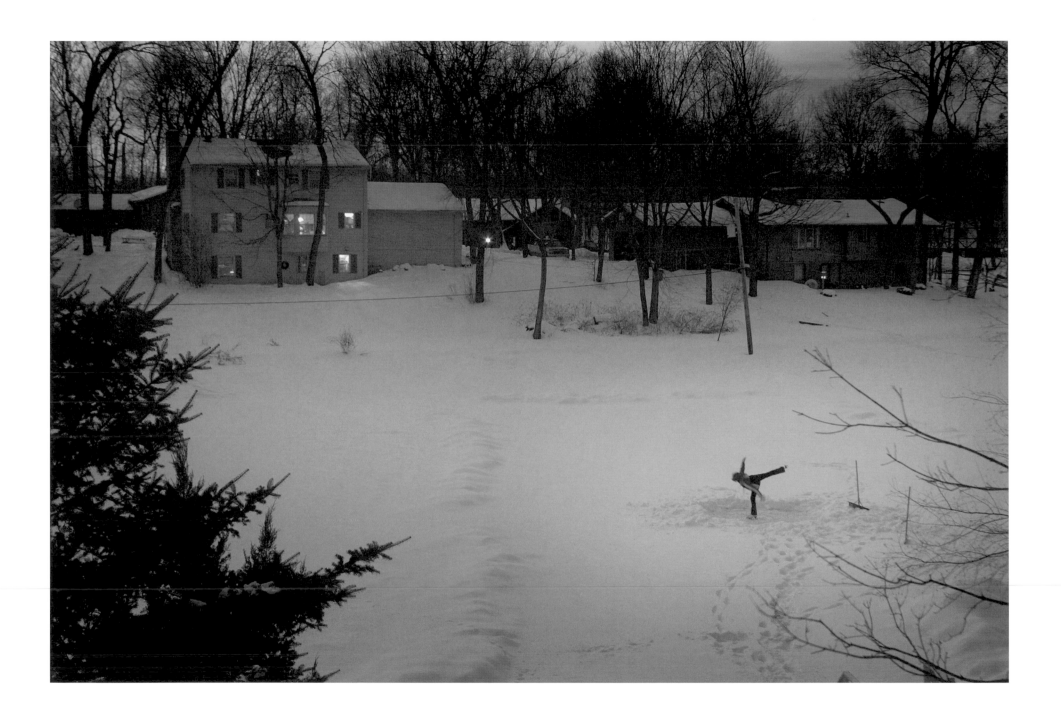

The Bog
CARLA HAGEN
Waskish

CARLA HAGEN
is a writer and attorney who is
currently working on a novel set
in the 1930s on the Minnesota-
Canada border. Her work has
appeared in *Sing Heavenly Muse!*,
Gypsy Cab, and *100 Words*. She
grew up on a farm in Lake of the
Woods County and spent a lot
of time in the woods, on the
Rainy River, and around the big
lake. Her mother taught her to
love language, how to spot wild
ginger, and how to tell a white
pine from a Norway.

WHEN I DRIVE ALONE FROM ST. PAUL to my native Lake of the Woods, I call my mother from Kelliher or Waskish. "OK," I say, "I'm heading into the Bog," which means that if I haven't arrived within two hours, she'll call the sheriff and have him drive south from Baudette down Highway 72, just to make sure I haven't been sucked into the mysterious depths of the Bog, unknowable like God, always in the singular and capitalized, as if it were the only one in the world.

The Bog's huge expanse of peat—muskeg to people from Lake of the Woods—begins just north of Waskish: mile on mile of tamarack, jack pine, gnarly scrub brush, and sumac, all of it growing on top of a strange terrain that is both prickly and marshy. In the spring, water rushes iron-red through the deep ditches that border the road, and the Bog is wet and treacherous as a sponge. Fog rises in the cool evenings. In late summer, after blueberry season, the ground dries out and becomes crunchy. Then, in the fall, sweet-acrid smoke curls up and drifts across the roads. The first settlers tried to clear the land by burning it, but the fire sank into the peat, which has smoldered ever since. Its smell means the onset of fall, of red sumac and golden poplar and wild hazelnuts in the woods. For me it means crossing the Bog at night, scanning the road for deer, the car tunneling through the fragrant, smoky haze.

Few stations bubble to the surface of my car radio. Maybe it's interference from the ghosts of disappointed farmers or from the abandoned radar base that, during the Cold War, used to search the sky for enemy planes flying in over Canada.

I shudder as I remember how Rudy Perpich once proposed mining the Bog's peat. I vowed to lay my body in front of the bulldozers rather than surrender to the development of this unruly chunk of Minnesota's border wilderness.

Luckily I never had to make good on my threat. This winter, when I drive north through the Bog, I may see a wisp of smoke pierce the snow lying heavy over the mossy hillocks, a reminder that the muskeg still burns deep in the untamed ground.

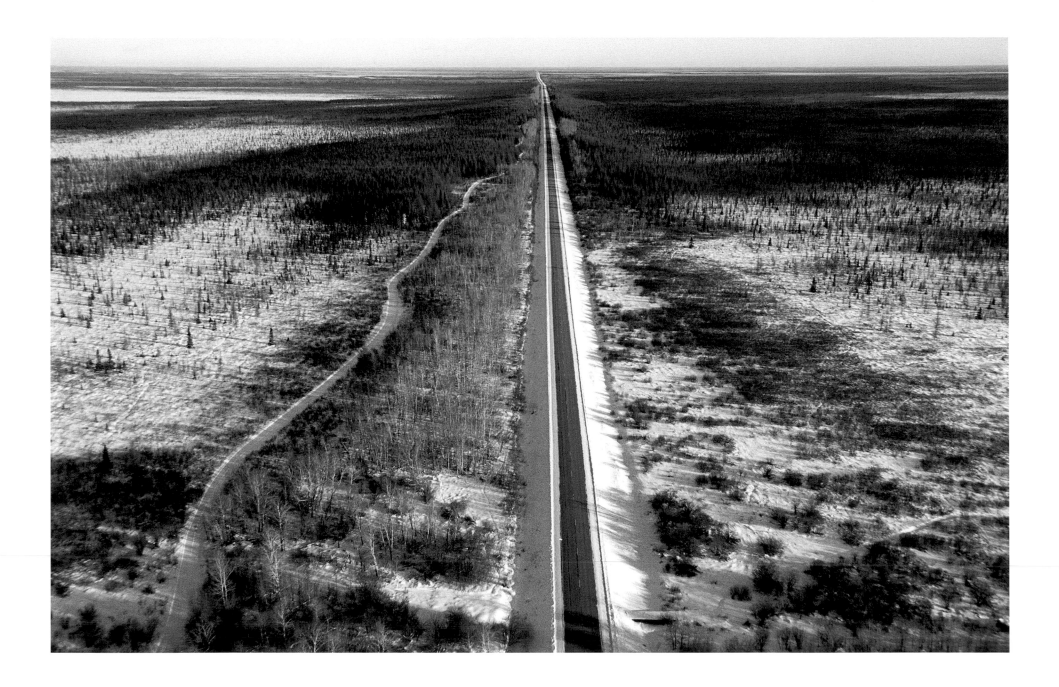

Winter on Lake Calhoun

CAROL DINES

Minneapolis

CAROL DINES
teaches writing and storytelling in Minneapolis schools. She has published two books for young adults: a novel, *Best Friends Tell the Best Lies*, and a collection of short fiction, *Talk to Me*. Walking is a lifelong passion, and she particularly enjoys city strolls and walks around lakes. She recalls from an early age her family's yearly tradition of planting one thousand trees at their northern Wisconsin cabin. Her love of nature includes both the dense urban gardens of her Lake Calhoun neighborhood and the wilderness areas further north.

LOST KEYS, A BABY'S BOOTIE, NAMES SPELLED IN FOOTPRINTS —mysteries! My standard poodle sniffs fish blood near a blue hole, now frozen over. A snowman stands further out, a red scarf abandoned around his neck, an empty wine bottle planted in his arms. I follow two pairs of footprints, one moving close to shore, the other branching off. The smaller footprints circle back, then turn sharply toward the middle of the lake, merging with the other footprints. Was it a game? An argument?

Standing in the middle of that wide, frozen tundra, I hear nothing but my own heart beating. It is a safe loneliness: to stand on Lake Calhoun in winter surrounded by a city of a million people; to hear no sound except the wind as dances of whirling snow whip the empty space; to be in a place so public and yet remain anonymous; to be so close to civilization and at the same time beyond the city's sounds. Here I return to my childhood, when the world that was visible from where I stood was enough and seemed the very center of the universe.

Four o'clock, wind-chill below zero; shadows deepen across the ice. The fishermen light their kerosene lanterns. High-rises glitter in the distance. The dog people arrive at dusk. We remove our dogs from leashes and set them free. Dogs are social animals, and reluctantly we follow, watching as they chase and circle until steam rises off their fur. Our faces hidden beneath scarves, bodies bundled, backs to the wind, we tell our lives: where we are from, why we are here.

A day in April: water glistens at the northern edge of the lake and I hear it—the ice singing! It sings its final moments of existence. Like everything miraculous, it happens only during a concurrence of unusual circumstances: a dramatic thaw after a harsh winter. Diamonds of ice thrust wind-worn edges against the rocky shoreline: a chorus of watery bells, each with its own note.

There is much in the world that determines who we are—jobs, families, dogs, the places we live. Next year, I might be someplace else. But I will carry with me a solitude hewn by nature's extremes—wind, ice, snow. I will remember Lake Calhoun in winter and know that I could never be awake enough to breathe in all its beauty.

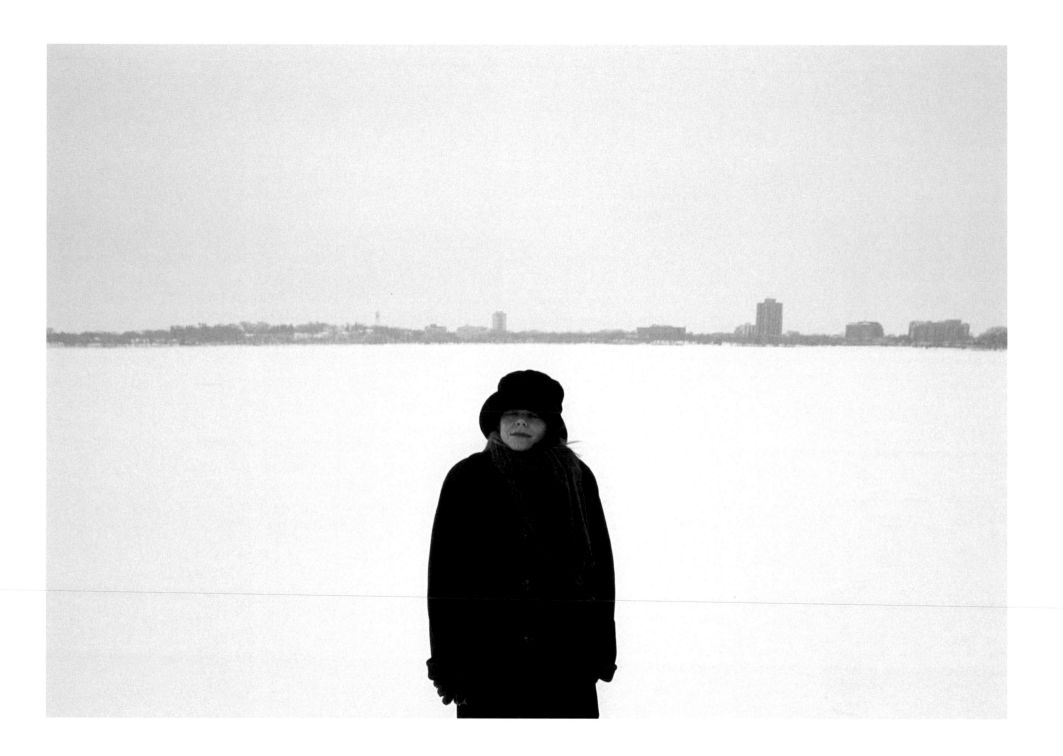

The Dirt Road
JERI NIEDENFUER

Cuyuna Iron Range

JERI NIEDENFUER
discovered the joys of walking on a dirt
road at age sixteen when her family
built a house in the woods north of
Crosby. "Going for a walk on the dirt
road was our entertainment and our es-
cape from captivity in the house. That
road is asphalt now, but then it was a
wide swath of fine white sand. In the
summer we walked barefoot. We walked
late at night. We walked in the winter
when it was so cold our eyelashes
frosted up. The smell of the sand mixed
with pine is what I remember most,
plus whippoorwills in the moonlight,
and pockets and pockets full of agates."
Jeri lives in St. Paul, where she is a
writer and jewelry maker. Whenever she
can, she leaves the pavement behind.

TIME SLOWS DOWN ON THE DIRT ROAD. For three miles or so it bends and straightens, rises and dips as it eases around lakes named Clinker and Mud. The road is Iron-Range red, ridged and stony. Each spring, during the muddy season, rumors of paving it reach our cabin. By August, when the yellow coneflowers are nodding in the sunny places along the road, such talk has died back. The way things are going, it seems likely that some spring morning our dirt road will tremble under the wheels and blades of heavy trucks and disappear under layers of asphalt. How to argue against progress? How to defend the ephemeral glories of a humble dirt road?

There's not much to see if you are driving on it: woods, weeds, a cattail-clogged swamp. But walking, you find balm for the urban soul: nature left alone. Here, trees and plants grow where they will. Dead wood is left to stand or rot where it has fallen. The weeds, which are wildflowers with names like toadflax and skullcap, yarrow and fleabane, yellow dock and vetch, flutter and hum with swallowtails, wood nymphs, damselflies. And all around yellow finches—flocks of them—and their friends fling color and music into the arc of clear light above the road. Your skin chills slightly as you walk by the swamp, especially if you are walking on a moon-lit night. You breathe the cool boggy air and feel nourished.

Some of our best walks have been in arctic temperatures. It's never too cold to take a walk on the dirt road. We tramp out of the warm cabin—two brothers, four sisters—into the vast white stillness that winter creates. The primal cold rouses our tribal instincts. From time to time we break our walk and form a circle of white breath clouds and tamping boots. The cold stings; our fingers are numb, but ice crystals glitter in the air and views are long through the unleafed trees.

On the dirt road, we feel the sharp sense of being alive.

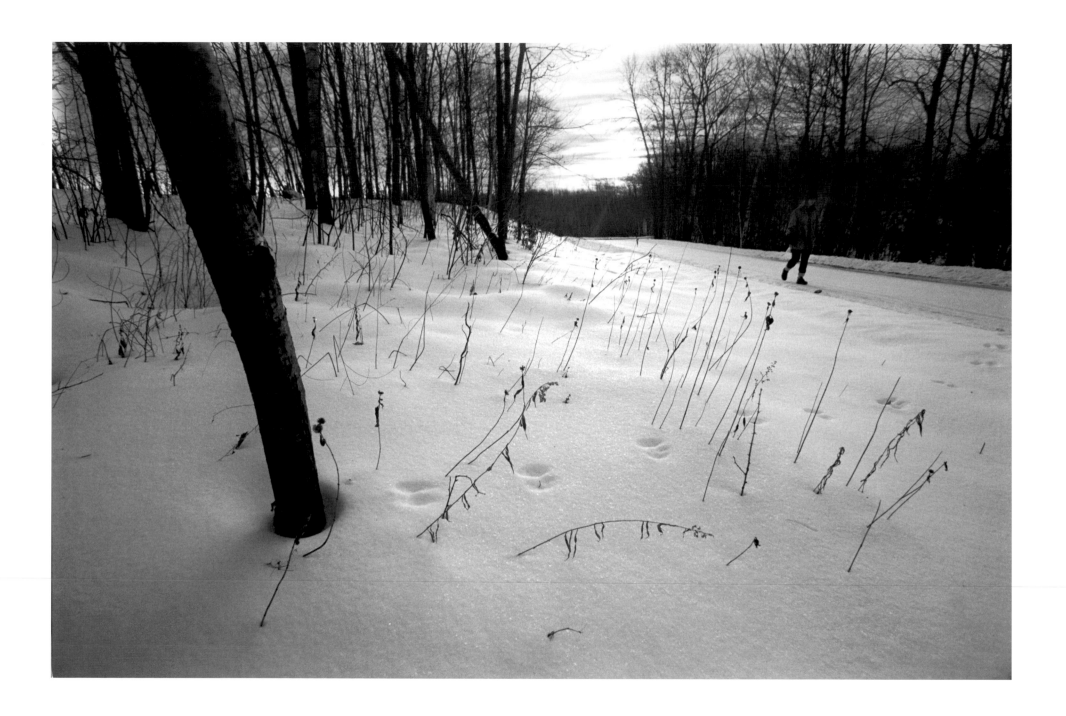

Powderhorn Park
ELSPETH KATE RONNANDER
Minneapolis

ELSPETH KATE RONNANDER spent her childhood near Powderhorn Park in Minneapolis, where sledding and skiing inspired a love for snow and cold weather. She now attends high school in Bemidji and aspires to be a writer and to study sociology. A lifelong hiker in Minnesota's wilderness, she prefers sun and fresh air, but running in rain and mud at crosscountry meets has taught her to appreciate all of nature's faces.

GROWING UP, I LIVED ACROSS FROM POWDERHORN PARK, Minneapolis's version of New York City's Central Park. After work and on most weekends, my dad took my younger brother and me to the snow-covered park to sled, ski, and enjoy winter.

My family had a blue sled we used until the duct tape could no longer hold it together. On weeknights, the southside hills were ours. On weekends, we ventured to the monster hill with the huge jumps on the west side. With enough speed gained on the hill, my sled would glide over the sidewalk and keep going out into the middle of the lake.

After a night of sledding, we would return home and stuff our wet mittens into the radiator.

My dad learned to cross-country ski back in the '60s at Powderhorn. Thirty years later, he taught me at the same park. At the top of the hill I placed one ski slightly in front of the other in my dad's tracks, bent my knees, and skied down the hill. I rated the many hills as beginner, intermediate, and advanced slopes. The winter of the Nagano Olympics, my dad snowshoed a giant slalom course for us. My brother and I would time each other. My brother always won. Each winter the park was covered in our ski trails.

For two winters I ice-skated on the lake. The warming house offered hot apple cider. Once my dad took my brother and me ice fishing.

I now live in northern Minnesota, with its abundant lakes, fields, and woods. City parks like Powderhorn are nonexistent. Yet, it is this snow-covered terrain I long for— an urban setting, complete with lake, fields, and woods. In my mind, I stand again on top of a hill, snow gently falling, the sounds of a bustling city contrasting with this quiet, peaceful, winter wonderland.

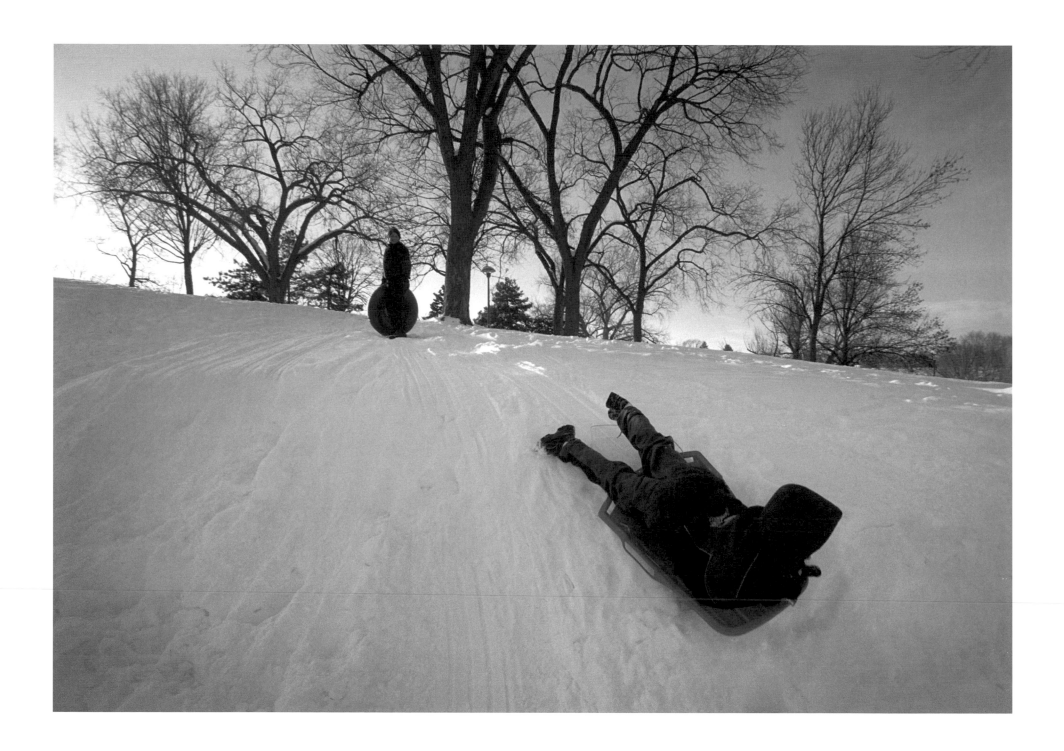

Holy Land
KAREN SCHLENKER
Hayland Township

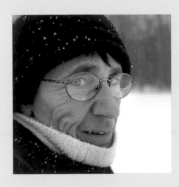

KAREN SCHLENKER
has lived in east central Minnesota for
nearly thirty years. Her work has been
published in *Blair & Ketchum's Country
Journal*, *Children's Digest*, and *Woman's
Weekly*, and she is currently writing a
history of rural schools in Mille Lacs
County. She doesn't categorize herself
as an "outdoorswoman," but she's al-
ways enjoyed the sights and sounds and
smells of nature. She credits the land for
drawing her out and teaching her many
things, and she is grateful to those who
have shared with her their knowledge of
and appreciation for nature.

I'M NOT SURE WHEN I REALIZED that our place is a holy place—when I started paying attention, or why—but at some point, I recognized it.

You can back into a place. You don't even know that it will become one of the most important things in your life. You just know you want some land, a good place to raise kids, a place you can afford. You find a place that meets some very broad and not-very-well-thought-out criteria, and you buy it.

We bought a half of a quarter-section of hay ground, cattail marsh, mixed hardwood forest on a low gravel ridge, with a hummock-pocked, overgrown old meadow. Neigh-bors, descendents of the first white settlers, refer to much of this as "wasteland."

Over the years, you realize that a place reveals things to you. When you first see it, you're agape at the carpet of trilli-ums in the May woods. Then you notice other flowers, too. You get a book about wildflowers and you walk the woods. You see startling colored fungus, tree bark you must touch to know better. Trees sprout leaves so green you can feel it

through your skin. Over months they mellow into summer leaves, then late summer leaves, then fall leaves of yellow, red, burgundy. You get snowshoes so that you can walk the place in the winter and listen to the frost.

The generosity of the place is humbling.

When my mother was dying, I went often to the field and the woods. This dying was fearful, and I needed guidance. I went out to stand in the gloaming of late winter evenings and gaze across the hayfield into the old poplars. This was the woodlot foresters scolded us for allowing to get too old, letting go to waste. The poplars and the snow-covered earth and the sky embraced me and warmed me. They showed me that there was shelter and support and harmony, and with this I could return to the nursing home and sit with my mother.

We didn't come to this place so that I could become a better person, or love more deeply, or see more clearly, but insofar as I have grown some in these ways, this place is responsible for it.

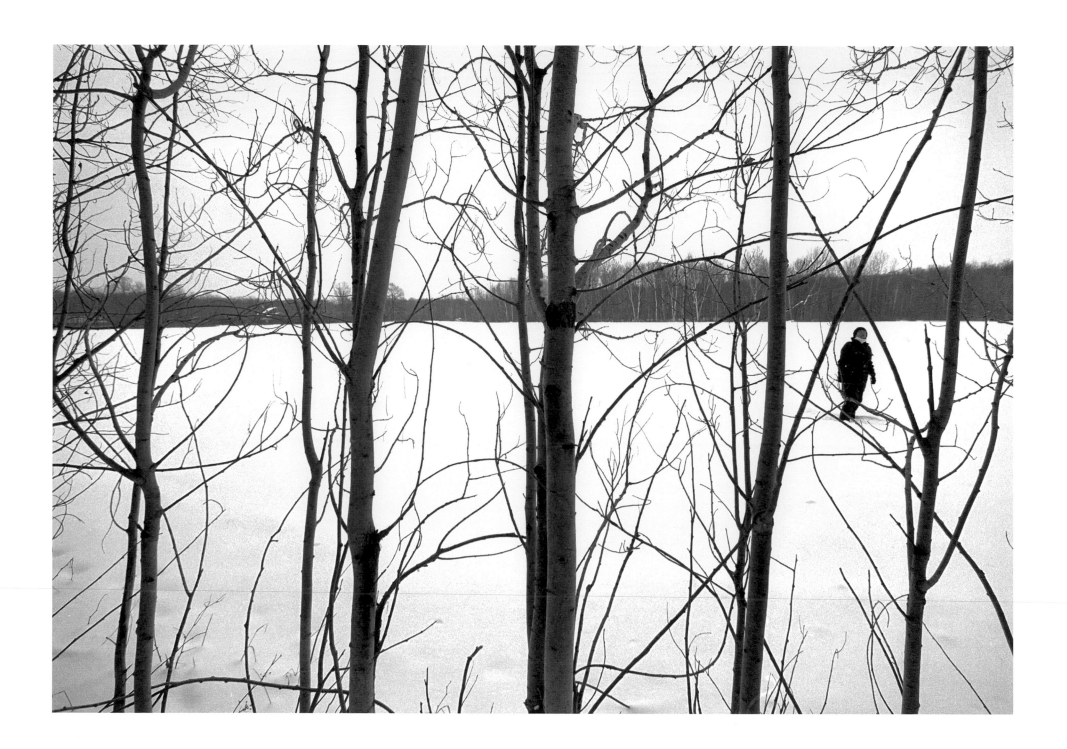

Park Point
LISA BRECHT
Duluth

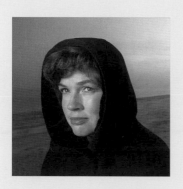

LISA BRECHT
has been writing from the moment she could hold a pen. She is a freelance writer for the website Chowbaby.com, a guide to restaurants in major U.S. cities. In addition to freelance writing, she produces greeting cards and hand-painted picture frames. Her hobbies include gardening, reading, wine tasting, and water sports. Lisa describes her affinity for the Duluth area, particularly the power Lake Superior holds for her: "From the first time I saw her, her whispers drew me in and her intimidating strength taught me respect for this land. The North Shore, in all her grandeur and beauty, has shown me that nature still has a place despite the growth of her people."

AT THE END OF A LONG ROAD beyond the canal of Duluth lies a park like no other. A transformation occurs as you enter Park Point in winter. Your heart cannot recall what you know to be true; your senses escape you. The lake beckons you and makes you her own. The park's playground equipment dares not peek out from under the snow for fear of the lake's wrath of raw, unadulterated cold. Not even the tranquility of the season can mend the grip that Lake Superior will have on you.

I truly cannot recall the season or even how I discovered this place. That first time, though, I knew that this was a place of great wonder and mystery. Park Point is my absolute favorite place at any time of year, but in winter the great lake grows dark and angry, keeping secrets yet somehow compelling you to listen to all she has to say. The waves tell a story of those who have come before you. Crashing upon the shore with reckless abandon and laughing as they turn away, they take a part of you with them. The winds show no mercy and words escape you, as does your breath.

Amid the swirling snow and immense cold, I realized my sudden vulnerability to the unimaginable depths of this great vastness. With a shiver, I pondered how the 700 *Titanic* survivors must have felt as they huddled in their lifeboats on that cold April night, praying for mercy from the unfeeling North Atlantic.

The homes along Park Point Road are festive during the holiday season, adorned with lights and pretty decorations. It is literally a winter wonderland, where homeowners invite visitors to get out of the car and tour their displays. At the end of the road, past the enchantment of the holiday lights, is a place of wonder and awe-inspiring beauty. Silent yet thunderous, it's a commanding presence in its own right: the place where Lake Superior embraces the point. Just a moment on this shore, a moment in the grips of its wintry embrace, and it will make you its own for a lifetime.

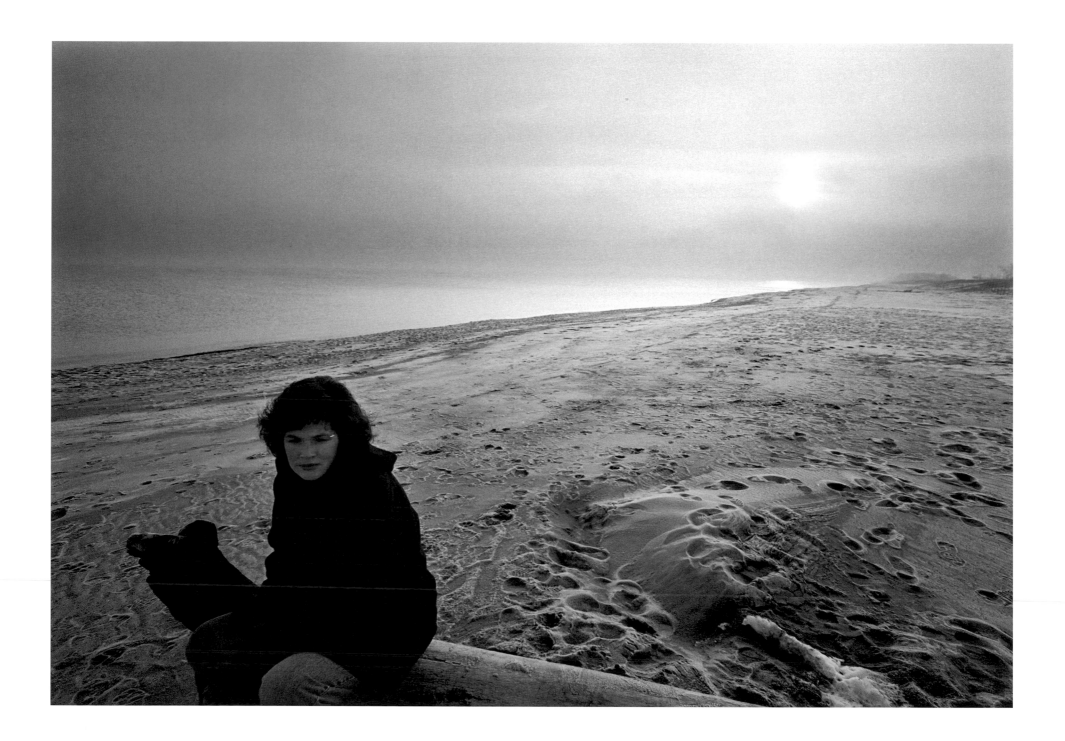

Heart in the Hill
MARY WOODFORD
Melrose

MARY WOODFORD
is a registered nurse who works in the
emergency room at Methodist Hospital
in St. Louis Park. She describes her in-
troduction to the power of nature in this
way: "About fifteen years ago, I watched
my dad gently place a little green frog
onto my young daughter's t-shirt.
It clung there, and instantly a memory
stirred. Another time and place, he was
there, holding a big swamp frog.
Another little girl, me, squealing with
benign fright." She has seen and shared
in her father's love of nature all her life.

WE CALLED IT SIMPLY "THE BIG HILL." We cannot agree who named it. There were ten of us—six girls and four boys—growing up on the farm near Big Birch Lake in central Minnesota. None of us could resist its call, and when our chores were finished, the hill became our playground. We readily embraced the hill's sanctuary and handed down its lessons child to child, year after year. We learned which trees were safe to climb and which winter incline best suited our sleds for a long run. We wove stories about the "Indian mounds," sank ramshackle rafts in its murky ponds, and followed meandering cow paths to nowhere.

I fell in love up there on the hill, cradled in the arms of a birch tree. That hill introduced my heart to nature's own. Amid the voices and laughter of my brothers and sisters, I learned to daydream, to build and create within. Now, fifty years later, that hill is my kaleidoscope, tumbling nature and soul together.

I have come to realize that the hill had no spectacular overlook and its size was really quite modest. But its lessons are not. Sometimes less is more, and nature demands that we look inward as much as outward. Beauty is not always gigantic. To a child, it may be a small niche carved in the soul that lasts a lifetime.

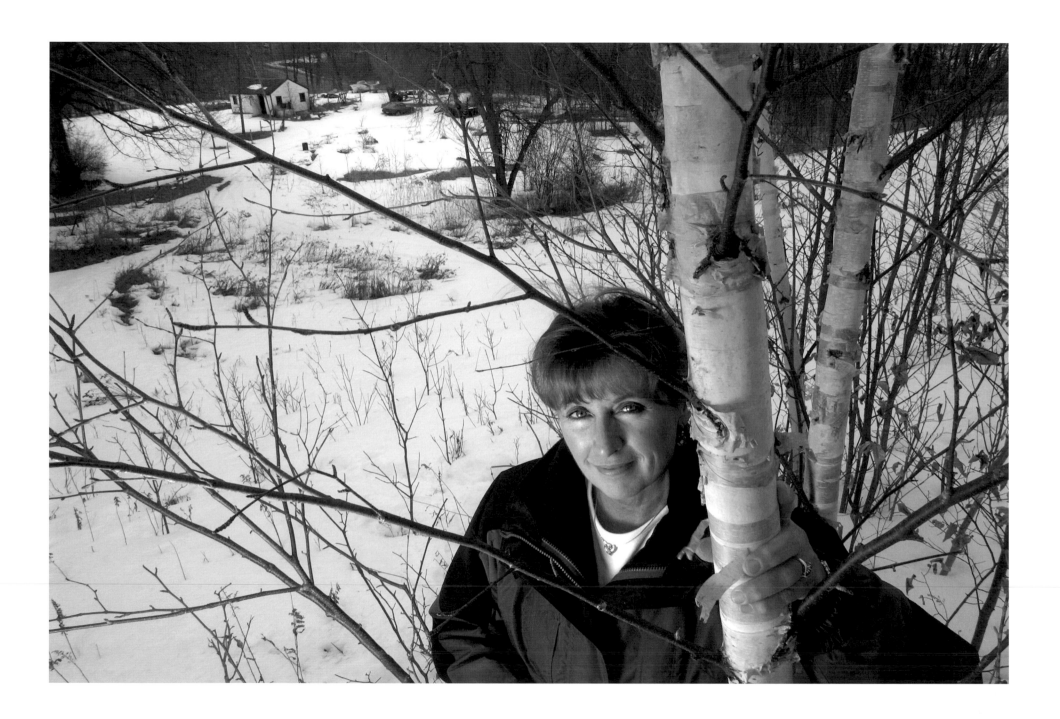

The Day's Last Glow
LACY BELDEN

Elm Creek Park

LACY BELDEN
cross-country skis to keep warm and active during frigid Minnesota winters, and she has spent many happy winter evenings in French Regional Park near Medicine Lake in Plymouth and in Elm Creek Park Reserve in Maple Grove. She grew up in Utah and Texas and now works as a mechanical design engineer in the Cardiac Rhythm Management Division of Medtronic. Lacy thanks sisters Susie and Heather and best friend John for teaching her to appreciate many faces of nature. Taking time to observe the creative power of God, from tiniest seed to vast horizon, has helped her to keep many of life's petty problems in perspective. She expresses herself creatively through painting and poetry, and she enjoys outdoor activities throughout the year's seasons.

JANUARY'S THAW HAS DULLED THE EDGE OF WINTER, but as I sit down to write about my wintry landscape of Elm Creek, I am hopeful.

On many late afternoons in the wintertime, putting the workday behind, I set my skis down on a trail at Elm Creek Park Reserve. At first, I'm cold and tentative—fingers and toes a bit numb. Frigid air prickles my eyes as I descend the first hill, and a tear streams down my cheek. But I'm determined to keep going, free to pursue a more natural pace, away from the brake lights in a river of traffic on Interstate Highway 94, out into the midst of a 4,900-acre landscape that is the largest of the Hennepin parks.

Up and down hills, through marshes, prairies, and woods, I shuffle, stride, slip, struggle. With each gasping breath, the silt that's been settling in my soul is churned up. As I climb each hill, I cast off the dregs of worry, pride, and anger—the natural byproducts of committee meetings, forty-five-minute commutes, and giant computer monitors in tiny cubicles.

By the time I've skied four kilometers, reaching the woods of the Eastman Nature Center, the heat of exertion is building in my core. The basswood seeds and oak leaves, still clinging to their trees, glisten in the last light of day. As I head east from the edge of the woods, rolling fields of sparkling snow open up before me. On either side of the trail, grasses stand in a golden salute to the sunset. I climb a hill with childish enthusiasm, eager to touch the full yellow moon rising in a frosty blue sky.

Atop this hill, in the wide-open space between the sun and the moon, small though I am, I am a part of the day's last glow. I thank my great Creator for a breath of life, this land, the snow.

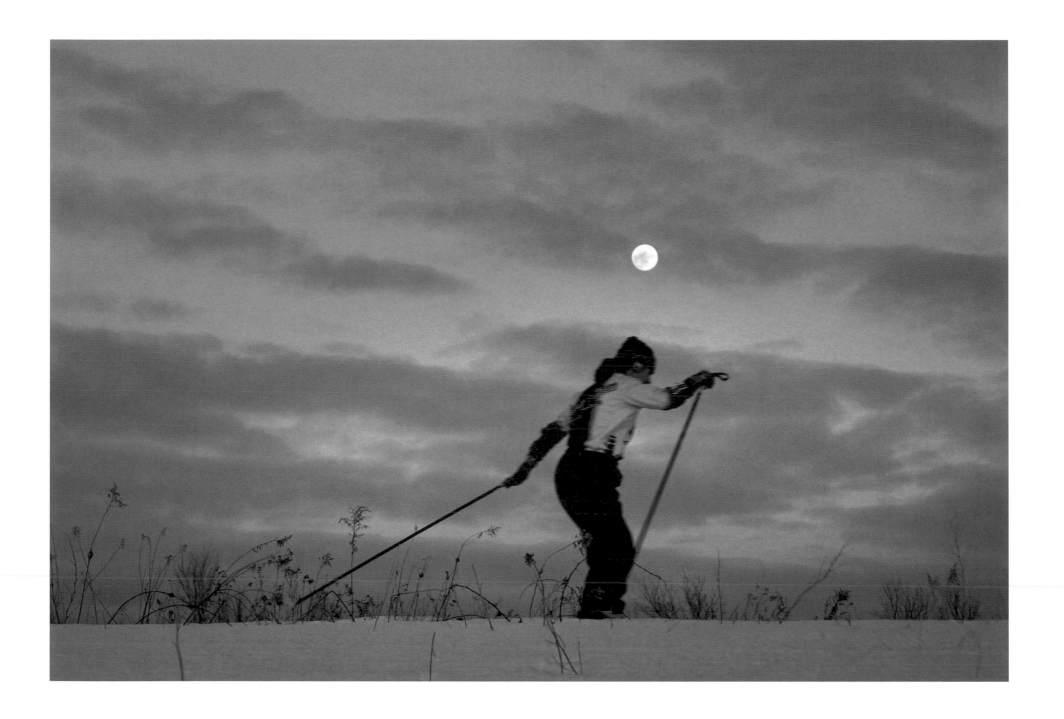

Tamarack Bog
LARRY SCHUG
St. Wendel Township

LARRY SCHUG
has been a recycling coordinator for the College of St. Benedict for twenty-four years. He has published four books of poems: *Scales Out of Balance, Caution: Thin Ice, The Turning of Wheels,* and *Obsessed with Mud.* He credits wife Juliann Rule with helping him develop a love of nature, acknowledging that she taught him much about the natural world and her appreciation for the environment, both of which have carried over into his career and his writing.

FOLLOW ME. Now that the ground is frozen, we can hike into the tamarack bog. Most of the year, this trek would be through knee-deep water and mucky peat. Mosquitoes would be showing us no mercy, but we might see a lady's slipper. We'll walk out past the "doughnut pond" dug by a previous "owner" of this property.

On the island in the center of the pond is an occupied beaver lodge. Three beavers live there, coming out from under the ice to eat from the stick pile of aspen branches and willows stored underwater for wintertime sustenance. Snapping turtles, painted turtles, and frogs are hibernating in the mud at the pond's bottom. After we walk through a stand of cattails—their brown tops split open, offering seeds for the wind to carry—we come upon a beaver dam that has created a pond on a small creek that spills out of Swamp Lake to the south. There are a couple of muskrat houses upstream from the dam. We can walk right across the dam, through more cattails and dry, yellow swamp grasses, and into the tamaracks where the ground is covered by faded gold needles and wisps of snow.

This time of the year the needle-less trees appear dead, the tamarack being the only conifer that sheds its needles in the fall. The tamaracks grow on humps of soil, each tree on its own little island in the bog. Some of the tamaracks have blown over, and their massive round root systems, intricate as spider webs and as big around as the base of a silo, have been pulled out of the soil. You can see that the trees have very shallow roots that spread in all directions.

This tamarack bog seems like a piece of the northern wilds transplanted. Here live whitetail deer, great horned owls, and even a pack of coyotes. On cold winter nights you can hear the coyotes yip and howl. The sound is so primitive that it's enough to raise the hair on your neck.

Legally, my wife and I "own" this property. In reality, we know that no one can own this eerie, primitive place.

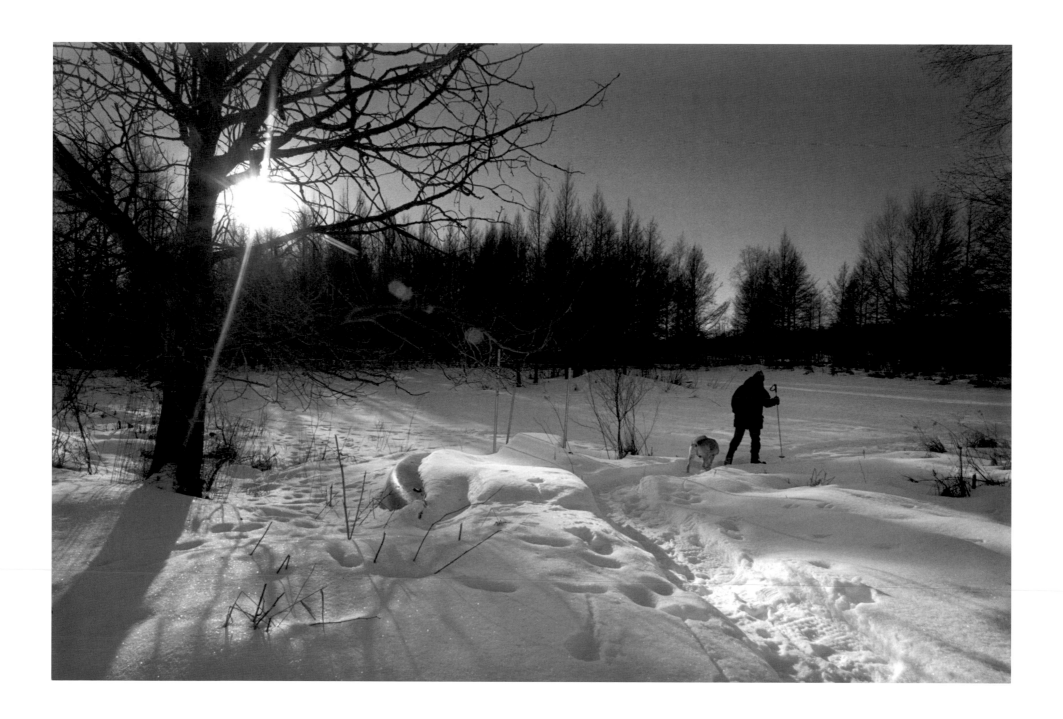

Wood Lake in Winter
GUSTAVE AXELSON
Richfield

GUSTAVE AXELSON recalls that he first heard the wilderness "singing," as Sigurd Olson has written, during a trip to the Black Hills of South Dakota: "I still vividly remember my astonishment at the sight of the Badlands, illuminated in majestic orange and yellow by dawn's first light. I remember my giddy excitement at spotting my first pronghorn, and the sense of purity summoned by a prairie breeze." Today the north woods sing to him, and he expresses his passion for the natural world through his writings, some of which have appeared in the Minneapolis *Star Tribune* and *Minnesota Conservation Volunteer* magazine.

AN EMPTY PARKING LOT IS A WELCOME SIGHT on this frigid winter dawn. It means I have Wood Lake to myself. Not that anyone else would go cross-country skiing in Richfield at 6:30 A.M. when the thermometer reads minus-five degrees.

As I venture onto the loop trail around the lake, it is easy to imagine that I'm hundreds of miles away in the heart of the north woods. My mind is at ease; the sound of swishing skis on unbroken snow relieves the anxieties of the workweek. To my left, blackcap chickadees chirp and dance about excitedly in the frozen tangle of cattails at the lake's edge. Within their midst is an out-of-town visitor, a dark-eyed junco who thinks Minnesota is a good place to spend the winter. I half-expect to hear a wolf's howl off in the distance, but as my ears strain they can only detect a truck rumbling down Interstate Highway 35W.

A bit further down the trail, I cross the lake on a wooden bridge. From here I can see the lake set before me as if by an artist's design—the icy blue surface glistening under the hot rays of the new sun, with clumps of cattails perfectly positioned against a backdrop of towering, barren maple trees. To complete the painting, a red fox takes a jaunt across the lake. He stops for a moment to let me admire his thick, ruddy winter coat. Then he disappears in an insouciant trot, his tracks joining others in a chronicle of the lake's winter travelers.

Back at the entrance, I hear what Sigurd Olson called the "nasal twang" of a white-breasted nuthatch. I catch a glimpse of him clinging to a tree just before both he and I are startled by the roar of a Northwest 747 coming in for a landing. Such is to be expected when enjoying nature in Richfield, but for those of us who are urban dwellers by necessity and not by choice, Wood Lake is a cherished oasis, a place where you can watch a fox cross a lake when the clock reads 6:30 A.M. and the thermometer reads minus-five degrees.

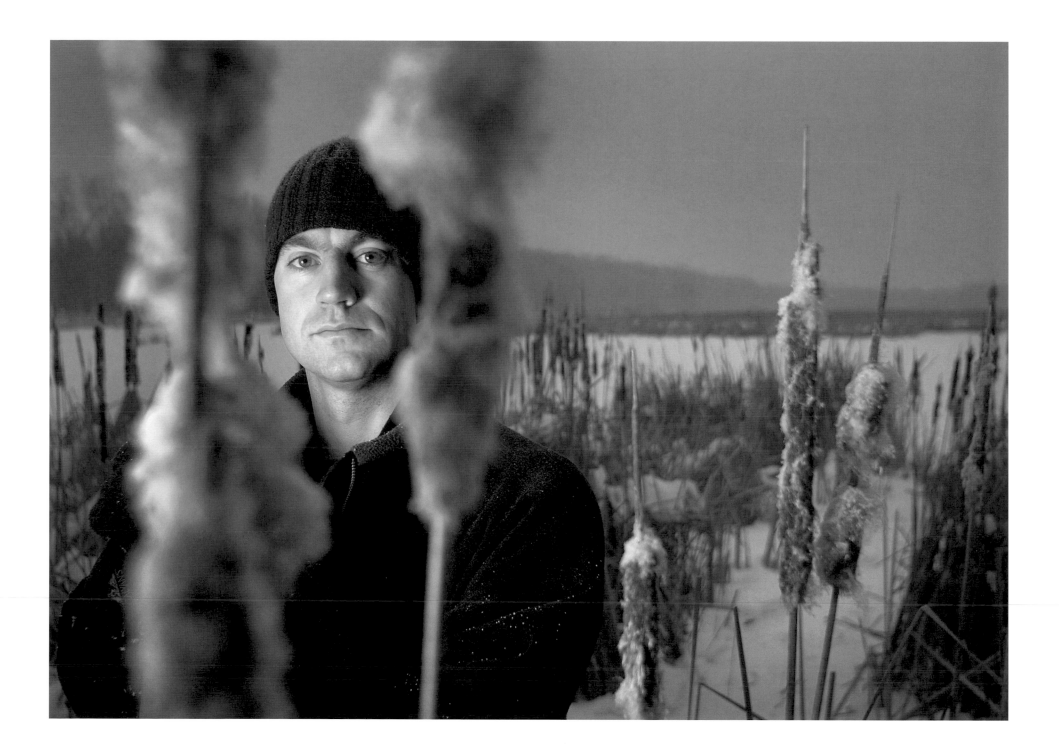

Spring

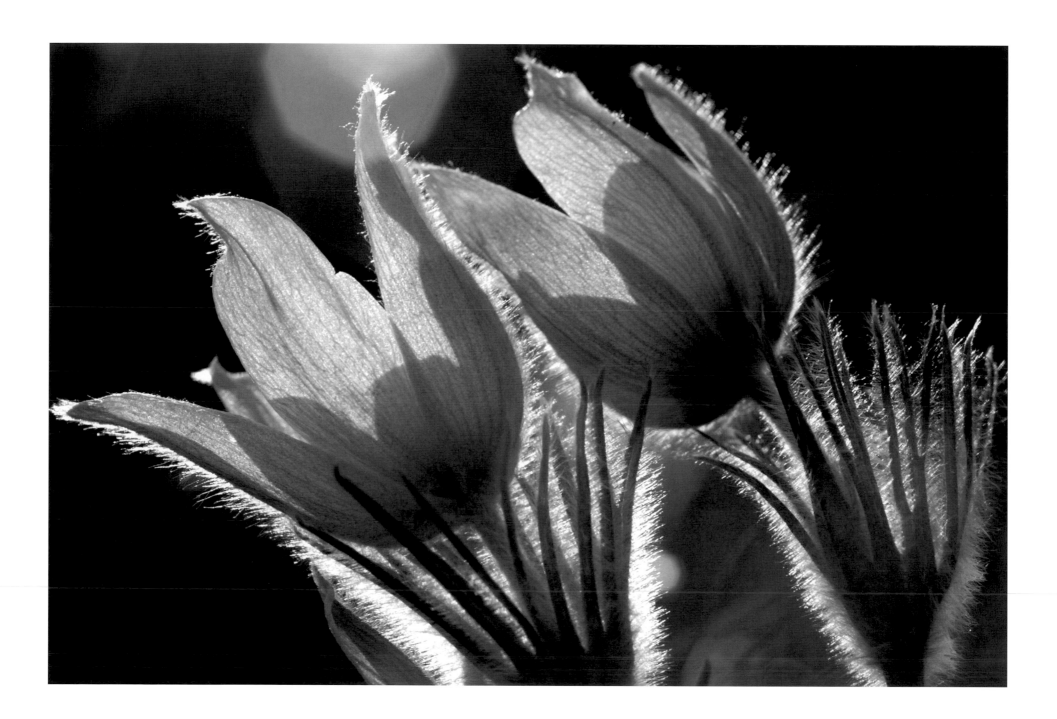

Meditations
JOAN JARVIS ELLISON
Pelican Rapids

JOAN JARVIS ELLISON
has farmed with her family for twenty years, and this occupation has made nature a part of her life: "Walking the fence line in the rain is not the same as dashing to your car between the raindrops: you appreciate the drenched colors of trees, the rain on your face." Her mother taught her to recognize wild flowers and constellations; her father taught her his love of trees. Her book *Shepherdess: Notes from the Field* recounts her experiences raising sheep and was honored with a Minnesota Book Award in 1996. She is currently working on several books and writing in the Japanese poetical form *haiku*.

LAMBING, MY FAVORITE TIME OF THE YEAR, begins around March 1. In our part of west central Minnesota, early March can be a cold, snowy, windy place. So we lamb in a barn and we check the sheep every three hours to see if any need help lambing or nursing. As we move through the month and the barn fills with lambs, we all get more tired and the house and our clothes get more dirty. One daughter takes up the slack by cooking supper and doing the laundry. Another daughter comes home from college to help out during spring break. My mother, a city girl from the day she was born, fills in at the farm for my husband when he has to go to work at his real job. We check ewes, check lambs, tag ears, dock tails, and give shots. We feed the sheep and ourselves. We fill water buckets and clean pens. We work and we work and we work.

During lambing, I am more exhausted than I have ever been in my life. Lambing is an emotional tug of war: the ecstatic high of saving a lamb, the crushing blow of losing one; the constant drive to be everywhere at once, the opposing need to slow down, to appreciate the wonder of each birth.

Without lambing I wouldn't see the stars gleaming in the velvet black of the sky at 3 A.M. I wouldn't appreciate the fragility of life or the fact that I can make a difference between life and death. I wouldn't stand at the gate and watch the horizon wash with peach a full hour before the sun climbs above the trees. I wouldn't lie in the snow behind the barn to listen to the snowmelt dripping off the eaves and feel spring seep into my bones.

With only fifty ewes, my sheep are not a large part of our income, but they are a large part of our life. We have been farming for eighteen years now. Sometimes I think, "Why are we doing this?" Then I answer myself. The farm is what keeps us connected to the earth, to our feelings, to each other. In the fullest sense of the word, the farm is what keeps us alive.

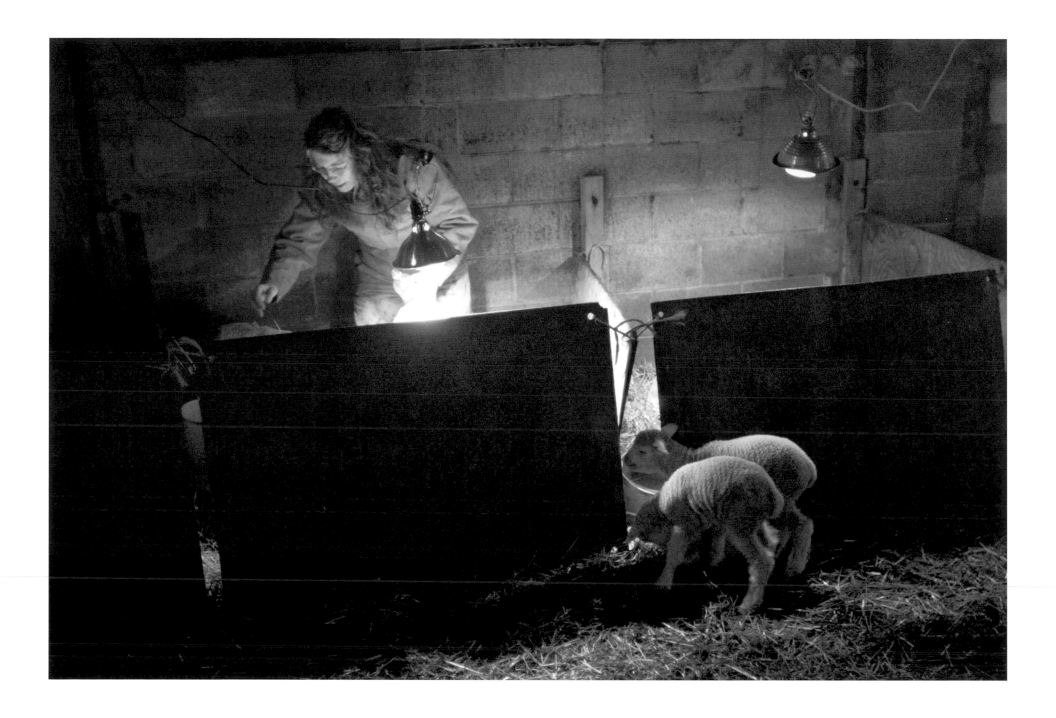

Pigeon River
JOANNE HART
Grand Portage

JOANNE HART
was born in New Jersey and raised in New York, but she has been a Minnesotan since 1949. Her poems have been published in the chapbooks *The Village Schoolmaster, In These Hills,* with drawings by Jayne Gagnon, and *I Walk on the River at Dawn*, with drawings by Betsy Bowen. She collaborated with visual artist Hazel Belvo on the book *Witch Tree*, which tells the story of *Ma-ni-do Gee-zhi-gance*, the Spirit Cedar in Grand Portage. She learned respect for organic life from her parents, who were gardeners, and her insights have developed over the course of her simple "back-in-the-woods" life on the Grand Portage reservation.

INTERNATIONAL BORDERS may be just lines on a map, but they carry mystique because they often are drawn after dispute, long arbitration, even war. People stand on the abutment here where a bridge used to cross the Pigeon River and say, "That's Canada? Canada!" This spot was the border crossing from 1917 until 1964, when the highway and bridge were relocated closer to Lake Superior. For me, the mystique is in the living river itself, not the history.

My cabins overlook the rock canyon. The river, running toward Superior, sounds constantly with shouts and whispers as it rushes over rapids. Sometimes, from certain places on the bank, I swear I can hear singing, though no one else is around. Other times the river is as loud as a waterfall.

Because the soil is thin over this rocky land, rainfall quickly flushes small creeks to the Pigeon and flows through crevices in the rock cliffs. One day the water is low, and then after a downpour, as if it were a huge rain gauge, the river rises up canyon sides and submerges boulders.

I know I need to be ready for cold weather when I see ice forming around rocks and outer edges of the current. Winter arrives in late December or early January, not so much with snowfall as with silence, when ice seals the river's throat. A first sign of spring, while deep snow still covers the land, is the light voice of water calling up through cracks and overflowing frozen surfaces. Dramatic spring break-up comes with pieces of ice big as houses crashing loudly downstream.

A few years ago the Grand Portage Band of Lake Superior Chippewa passed a Reservation Land Use Ordinance that zones land along the Pigeon River for preservation. The Tribal Council acquired my acres and gave me life estate, which means that after I die, all signs of my being here, the cabins, will be destroyed or moved out. This pleases me because in the zoning decree I see a strong affirmation of Indian respect for more-than-human life. My years here have taught me that the rocks, the trees, the river are indeed alive and changing, long before and long past my time.

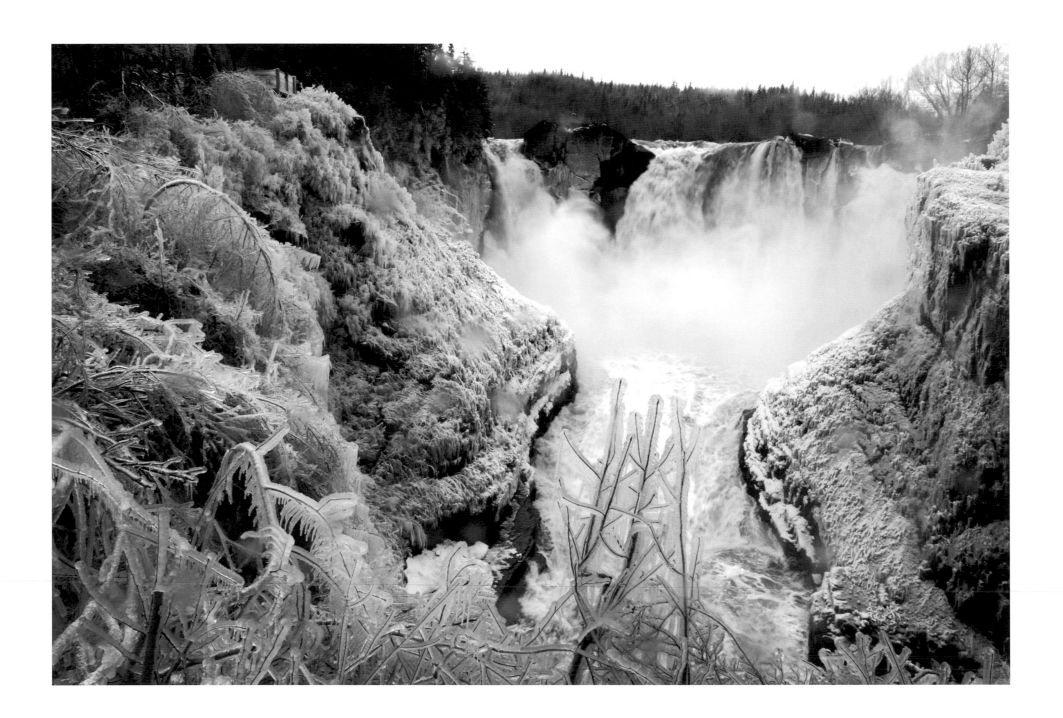

Helen Allison Savanna
DON KADDATZ
Anoka County

DON KADDATZ
grew up on a dairy farm south of
Cosmos. A taxidermist who taught
biological sciences for thirty-five
years in Clarissa and Mora, he has
always been fascinated by nature
and the outdoors. Biology became
a lifelong study after his introduc-
tion to it as a college freshman, and
he credits graduate professor Max
Partch for captivating him with
lessons of ecology and the natural
community. He now examines and
photographs natural areas in order
to share them with others.

THERE IS A NATURAL and very special place just north of the Twin Cities. It's a savanna, preserved by a purchase in 1960. It is maintained by The Nature Conservancy and is now part of the Scientific and Natural Areas system. The savanna encompasses only eighty-six acres, but after I walk only a few yards I lose sight of roads and buildings and am swept back in time to what the first European pioneers to our state gazed upon and settled. This rolling carpet of prairie grasses and showy flowers interspersed with the twisted branches of the bur oak trees must have openly welcomed them. It is an inviting place, and that is probably why we as a people have built on and destroyed most of our native savannas.

The first time that my wife and I visited Helen Allison Savanna, it was to locate the first blooms of spring, the pasqueflowers. Finding them has become an annual ritual that refreshes the spirit after the starkness of a long Minnesota winter. These visits have expanded to monthly adventures to witness the seasonal unfolding of the prairie grasses and colorful blooms, from the pasqueflowers to autumn's blazing stars and asters.

The summer sequence of penstemons and puccoons to butterfly weed, lobelias, and black-eyed Susans heightens our senses and colors the palettes of our memories with many vivid tones. All the while, the stately bluestem and Indian grasses are preparing for their bronze splash of color in the fall. And in winter, the truly beautiful bur oaks, with their gnarled, groping branches, shadow the still and dormant landscape.

Sitting on a ridge overlooking the park-like savanna, I sense the wilderness and tranquility in the odors and silence of the oaks and grasses. It rejuvenates my psyche, reminding me of who I am and from where my ancestors have come. But there is also a sense of urgency in the need to save these special places for someone yet to follow.

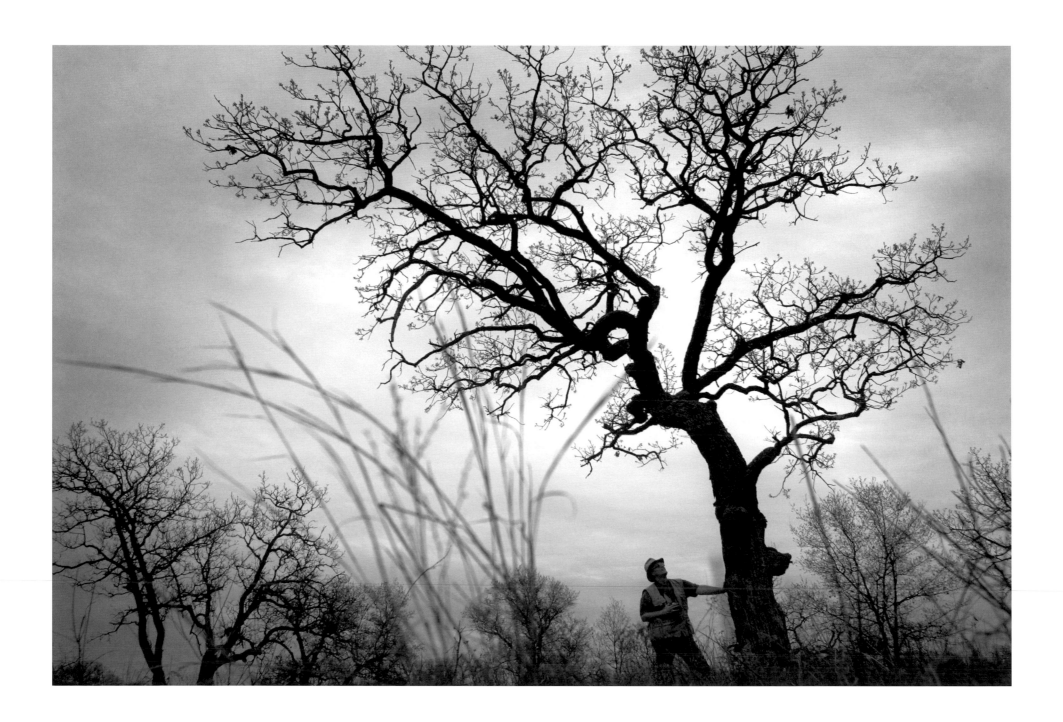

God's Own Hymn
ELEVA POTTER
Bemidji

ELEVA POTTER
attends high school in Bemidji and
enjoys writing stories and poetry. She
has lived in the woods near a swamp
and a lake for as long as she can re-
member, and she has always relished
exploring these natural places, whether
through hikes on the land or by kayak
and canoe on the water. She sums
up her observations: "Nature gives
me a place to be alone, to enjoy
the beauty of our world, and to think
about my place in it."

THERE'S A PLACE IN THE WOODS near my home where I often go. I sit on a fallen ash tree in a swamp with moss, ferns, aspen, and paper birch for company. I sit and think about my life, my future, the world—and why there are so many dang mosquitoes down here!

I often romp around with my dog, finding undiscovered treasures of yellow water lilies, morel mushrooms, and lady's slippers. The towering trees sway in the cool lake breeze as the robins and spring peepers sing their evening song. And as the wind dies and the lake becomes as smooth as glass, I listen to the eerie soprano chant of the loons singing their ballads to the starry night sky.

I sit and listen to the swamp sounds, with each creature playing its own instrument with its own melody, and as their music joins together it becomes the greatest symphony written by the greatest composer—a song no one can describe. It lifts up my heart and makes me feel that I am listening to God's own hymn. There is no way to recreate this sound: It comes from the depths of the earth and the souls of the animals; it comes from the lapping of the water and the rustling of the cattails and reeds.

If the animals ever die out because their homes are destroyed, if the vegetation is mowed down and the trees are felled, if the lake water is tainted—the symphony will be no more. If any one part is silenced, the music will be forever incomplete and never as pure, clear, and true as it once was and was meant to be.

If this ever comes to pass, our children will not be able to sit in their back yards and enjoy this great song of the wild as I have.

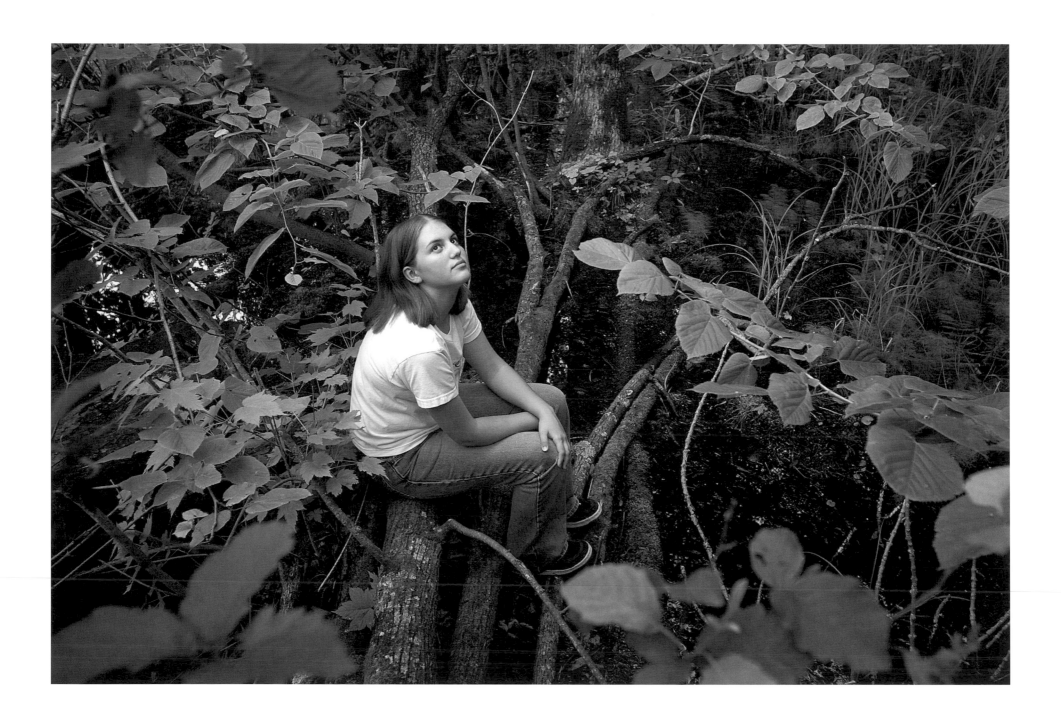

"Lots for Sale, with Lake View"
JEAN SRAMEK
Duluth

JEAN SRAMEK
has been a writer, performer, and
producer with Duluth's Colder by
the Lake Comedy Theatre since
1983 and currently serves as its
artistic director. She has written
scripts for radio and stage pro-
ductions, and she cowrote the
libretto for the CBTL's *Les
Uncomfortables*, the acclaimed
original comic opera about
Daniel Greysolon Sieur duLhut,
which premiered in April 2001.
She lives in Duluth with her
husband, John Bankson.

YOU'VE DRIVEN BY IT A THOUSAND TIMES. I wouldn't even know about it except that John and I took a "wild edible plants" community-education course and this was our field trip. Now it's our secret; we're wary of sharing. Can you be trusted?

It's bordered on two sides by busy highways, on the other two by apartment complexes and ranch-style houses, their gardens perfect rows of showy non-native exotics accented by gas grills. Large signs proclaim, "Lots for Sale, with Lake View." Lake view, shmake view. The real prize is the ground view.

A few yards away from car exhaust and left-turn lanes, there's a perfect cedar bog, an entire ecosystem with sphagnum moss, stemless lady's slippers, wintergreen, Labrador tea. Follow the path in another direction (careful not to step on the nodding trillium—descending trillium? We'll look it up in the field guide later) and a kaleidoscope of spring ephemerals appears. The traffic noise is quieter here, and it's a good thing because the clintonia and bunchberry and bloodroot are shy, marsh marigolds hate being called cowslips, and I can't listen and concentrate on the smell of wild leeks at the same time. Walk north; follow the frogs. We baby-step, but they know we're coming and shut up. The marsh is a textbook perfect-imperfect tangle of mosquitoes and rushes and blue flag and silently miffed frogs who know we have seen them naked.

It's raining and cloudy today, but I want to take a nap here, right now. I want to spend the night here. I want to buy all eight lots. I read a story about some youths who saved their town from development by vandalizing the "Lots for Sale" sign, adding zeroes to the price. But I'm an adult and my only chance is to get enough money to buy "Lots for Sale, with Lake View" before "they" do. "They" will put up condominiums and a ten-minute oil change and a video store and french-fry mulch around generic trees.

Bad teenagers come here to drink beer. They have rusty lawn chairs set up around failed fires of green wood. They have no respect for nature. But at least they only think they own the place.

The "Lots for Sale" signs have a phone number that I copy down and call later. I am a jealous lover, and I hang up when someone answers.

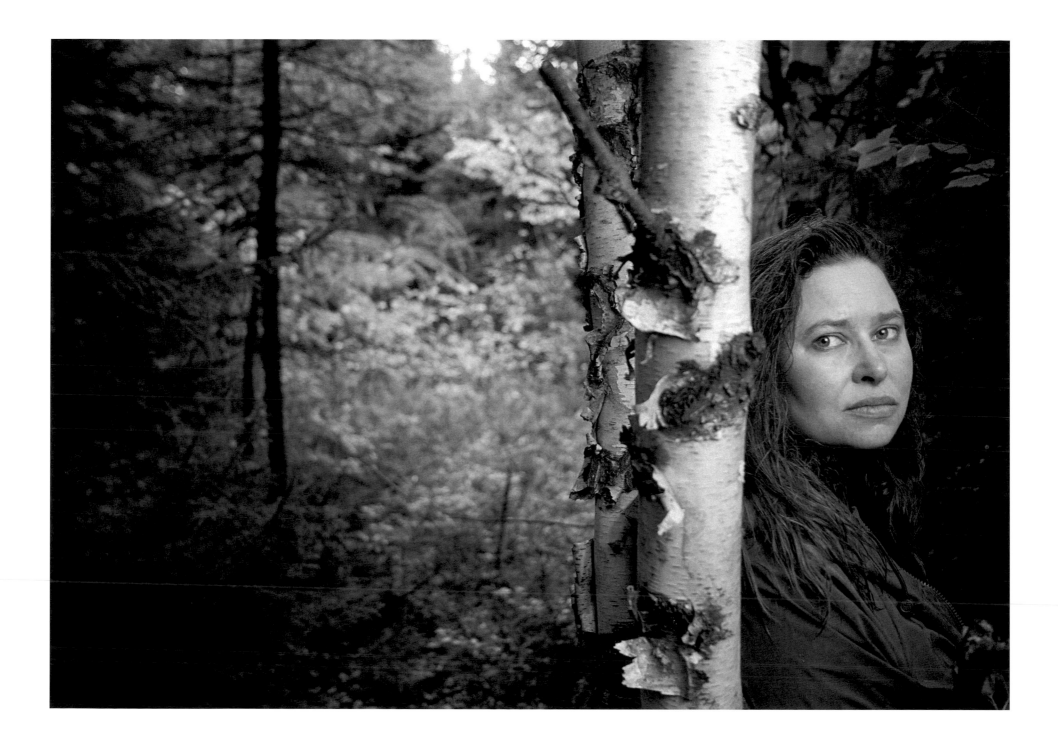

Cedar Avenue
JAN PETROVICH
Side Lake

JAN PETROVICH
enjoys walking through the woods and
along the lakeshores of Minnesota, where
daily worries are erased by fresh air and
woodland sense. She remembers visits
with her grandmother, who shared the
secrets of the woods by naming plants,
their medicinal uses, and their propaga-
tion techniques. Her grandmother
encouraged her to "listen to the song-
birds, the calls of loons, and the rustle
of the northeast wind to know whether
the fish will bite." Jan is a member of
the Minnesota Society of Children's Book
Writers and Illustrators, and her story
"Platypus Paddock" was published in an
Australian anthology.

MY BARE FEET SLOWLY JOURNEY over the mossy boardwalk to the old log cabin. The scent of wet cedar draws me to this tribute to Minnesota forests of old. Faded curtains wave in a breeze that whistles through chinking of moss and bark. Ascending steps in need of repair, my feet are gently brushed by bluebells from gardens past. Through the open door I see the twinkling lake, calling me to save its old friend, the Lodge.

Tar oozes from dismal ceiling repairs, yet sunlight glints across rippled hand-rolled windows. Outside, loons laugh and a meadow of buttercups buzzes with life. All is still inside. Never has a phone rung in here. It is a peace worth preserving.

Grandpa would tell us of his mother cooking on the wood-burning stove, children laughing, birthday celebrations and buddies from the war coming here for respite, fishing and wild times.

Long before his time, someone buried a frail china plate under the front step. Perhaps newlyweds made this their home. The plate, a talisman for good luck, remains.

Records indicate that the original occupants were workers. This cabin provided shelter for men who cut ice out of the lake, packed it in sawdust, and sent it by rail for a growing nation to use. They came from Europe to the frozen forests of Minnesota.

Wood creaks in the rustling wind and I'm drawn again to the damp smell of ancient cedar—Minnesota cedar, sawn by hand, dragged here by horses, and still standing.

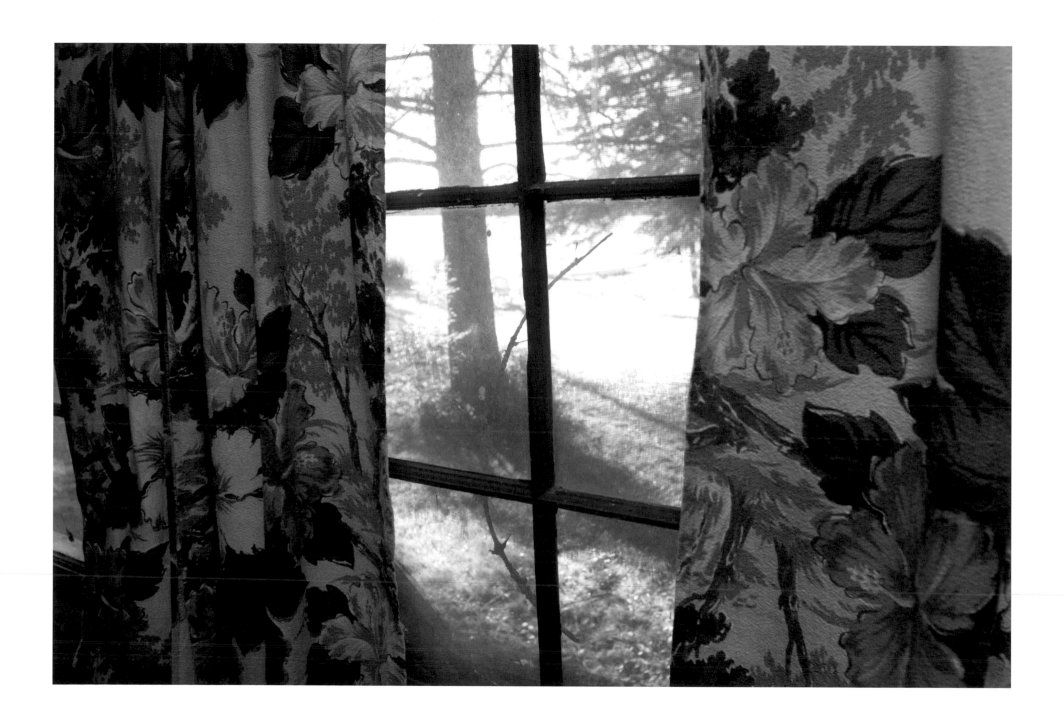

First Love
NEWELL SEARLE
Alton Township

NEWELL SEARLE
grew up on a southern Minnesota farm.
He has worked for Cargill, Inc., served as
deputy commissioner of agriculture, and
worked for nonprofit organizations. His
writing has appeared in the *Journal of Forest
History*, *Naturalist*, *Living Wilderness*, *Nature
Conservancy*, *Minnesota History*, and the
*Encyclopedia of Forest and Conservation
History*. His book *Saving Quetico-Superior:
A Land Set Apart* received the Forest His-
tory Society Book Award in 1979. Newell
first explored the relationships of humans
and land in Minnesota's fields, woods, and
wetlands, and over the years his explo-
ration of life has taken him to places as
diverse as Utah canyons, Wyoming grass-
lands, Ontario lakes, and Mexican steppes.

THERE IS A FARM IN ALTON TOWNSHIP at the end of a driveway off Waseca County Road 26. From its sheltering grove, the house overlooks fields that slope south to the banks of the Le Sueur River. This is where I first learned about culture and wildness, family and community, ecology and crops. Everything I love now, I loved here first.

My city-reared father, once a New Jersey man, has patiently improved this rundown farm until now, a half-century later. During our fifty-year odyssey, we learned that contour strips and grass waterways stop erosion, that drained sloughs don't always make good fields, and that re-stored wetlands aren't as fascinating as the real thing. And yet, despite draining, ditching, and tiling, the land forgave our mistakes, and, when we repented, the land responded with an abundance of corn and beans, deer and ducks, turkeys and fox. Year by year, our labors blended a landscape of fields and woods, fence rows and meadows into patterns not completely wild or domestic, yet harmonious as a whole. He has now retired the deep black soil fields as a conserva-tion reserve and signed a conservation easement that pro-tects our walnut woodlands.

It's May, and Dad and I pace off a new oak planting on a clay knoll near the river. He'll never see fully grown trees, but he doesn't mind. Oaks have taught him patience. Later, in the woods among beds of phlox, the grosbeaks trill songs that Dad's aged ears can scarcely hear. He checks an American chestnut, a nearly extinct tree, and is pleased that it's doing so well. Someday its nuts may help restore this blighted species to its former majesty. That's his hope for immortality.

With familiar fields now planted to grass and trees, I re-alize that we're done with farming and I struggle to under-stand what that means. One era ends, another begins. Time after time, I pick up handfuls of mellow earth to feel again its warm, loamy softness and smell its richness. I know that all good things come from it, but today isn't about land; it's about relationships.

In kindly twilight I ponder the mortgage this homely landscape has on my soul. I will never live here and yet I cannot leave. Even things that repel me—flat land, mos-quitoes, and humidity—are familiar parts of what I love. Like family quirks, they're infused with the memories of struggles and wonders. The stuff of life itself.

Earth to earth. Ashes to ashes. Dust to dust. Southern Minnesota lies so deep in my bones that the farm goes with me everywhere.

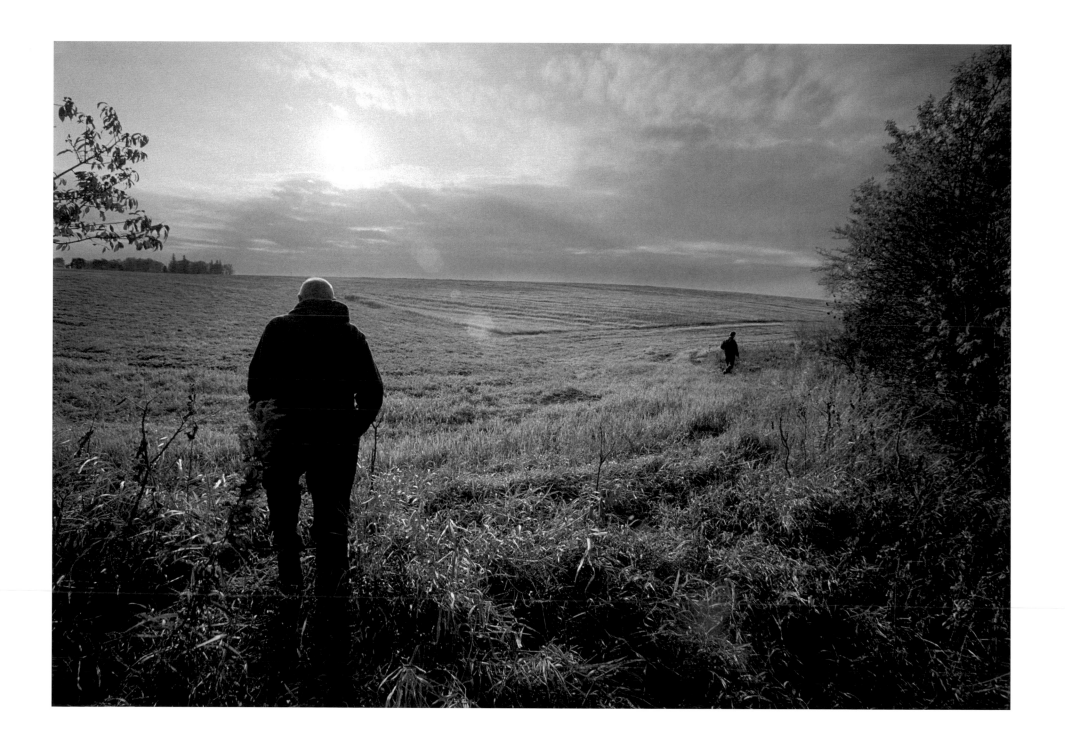

Picnic Highway
LORA POLACK OBERLE
St. Louis Park

LORA POLACK OBERLE grew up in St. Louis Park and has traveled Highway 100 all her life. She learned to love the Minnesota outdoors as a child during summers up north, when she sat on a birch limb that hung over the lake, dipped her toes in the water, and drank ice-cold, iron-tasting water from an outdoor pump. A freelance writer, she edits educational testing materials and has published three nonfiction books for children. Her favorite writing assignment involves another Minnesota highway: "Once, my husband and I traveled Highway 169 the entire length of the state, from Elmore to Ely, and wrote a story about the adventure. It was great fun."

NOW THAT THE NORTHERN PORTION OF HIGHWAY 100 is getting some much-needed updating, I'd like to mention some of the special things about this highway that will be leaving us as that third lane is poured.

First are the lilacs, the glorious, wonderful lilacs. In many places, Highway 100 is lined with these fragrant harbingers of spring. Those corridors of quiet purple beauty bring joy to the mundane task of driving.

Highway 100 is ancient in road years. Those lilac bushes were already old when I was a child in the '60s. Several of the bridges, especially those in St. Louis Park, were built as part of President Franklin Roosevelt's Work Projects Administration. They have character—an architectural solidity and grace—that's missing in most modern freeway overpasses.

But the most touching thing about Highway 100, I think, is something that's harder to spot. Look along the side of the road by the interchanges with Minnetonka Boulevard, High-way 7, or Highway 81, and you'll see stone picnic tables and benches, maybe a beehive-shaped stone fireplace. To me, this says something amazing, something hard to grasp at the start of the twenty-first century: Highway 100 stems from a time when people thought that the side of a highway was a fine place for a picnic, when the pace of life was such that drivers might want to stop.

It's hard to even imagine that kind of mindset. As we rush here and there today, our desire to cover more ground in less time is one reason why such reminders of Highway 100's past are doomed. Soon it will be as soulless as Interstate Highway 394 or the concrete maze that leads to the Mall of America.

So, for this spring, notice the lilacs. Look for the little stone picnic tables. Think about how life might be if it weren't so hectic. Of course, if you're sitting in a traffic jam caused by construction on 100, you just might have time for a picnic.

The author and her daughters, Tessa (left) and Paige

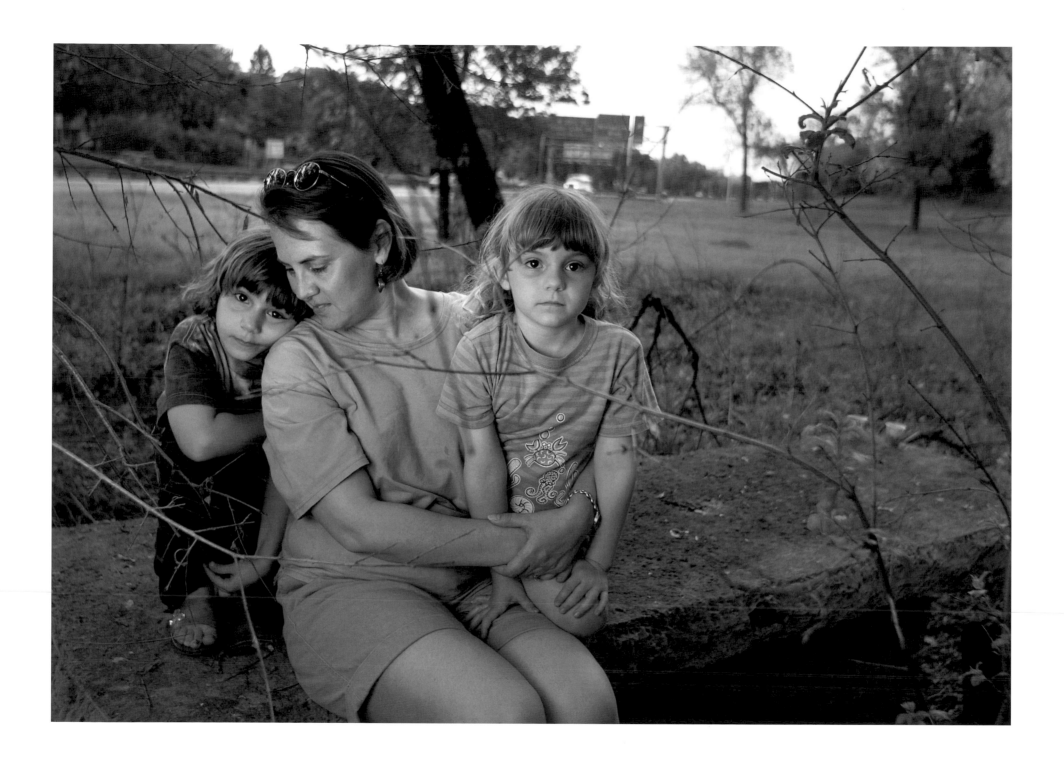

Another Minnesota
MARK VINZ
Moorhead

MARK VINZ
grew up in Minneapolis and near
Kansas City and now teaches at Min-
nesota State University in Moorhead.
His poems are paired with the work of
photographer Wayne Gudmundson
in the books *Minnesota Gothic* and
Affinities, and he co-edited two
anthologies of Midwestern literature:
Inheriting the Land and *Imaging Home*.
Growing up in Minnesota instilled
in him a love of the natural world,
but his greatest appreciation for the
state is inspired by Minnesota's
wonderful variety of landscapes,
especially the prairies.

FROM MY CHILDHOOD IN MINNEAPOLIS to the time
I moved back to Minnesota in the '60s after living in Kansas
and New Mexico for a few years, my image of rural Min-
nesota marched to the "sky-blue waters" drumbeat of the
Hamm's beer commercials. But the job that brought me back
was in Moorhead, in the prairie country of the Red River
Valley—so flat and uninteresting to me that I found it hard to
believe it was a part of Minnesota at all. Its saving grace was
a fifteen-mile drive east from Moorhead on U.S. 10, just past
Buffalo River State Park, where the road rises up to cross
the ancient beaches of Lake Agassiz and the rolling hills and
lakes begin.

But then, because our wives had become friends through
their work in the League of Women Voters, I came to know
Brom Griffin, at that time manager of Buffalo River State
Park. When Brom discovered how little I knew about the
region, he invited me to join him one evening for a walk
through the tract of virgin prairie just south of the park—
an experience that changed forever my perspective of
Minnesota.

Brom made that piece of land I'd so often driven by and
ignored come to life. His excitement in pointing out the
great variety of wildflowers and other plants was truly conta-
gious, as were his stories of buffalo wallows and Indian
camps and early settlers. It was then I must have realized for
the first time that I was living in the midst of a fascinating
landscape—not of the picture-postcard variety, but one in its
own way every bit as profound and enduring. As we stood
there at dusk among the big bluestem and coneflowers,
the cinquefoil and prairie plum and old man's beard, the
sky was more immense than I'd ever imagined—from an
ocean of scudding clouds to one dense with stars. More
than once I caught myself holding my breath in wonder.

Since that first visit, I've made many more to the
Bluestem Prairie Scientific and Natural Area (as it's now
called) and to other tracts of irreplaceable virgin prairie
preserved in this region. Trying in my own way to become
the kind of guide for others that Brom Griffin (who now
works at St. Croix State Park) was for me, I've continued to
learn about the prairie's fascinating biology, geology, and
history and the rich tradition of literature it has inspired.
And I keep coming back, delighting in its understated and
ever-changing beauty, its fragile complexity so full of sur-
prises, which I know now will reveal themselves only to
those who take the time to get out of their cars and learn
to see what's all around them.

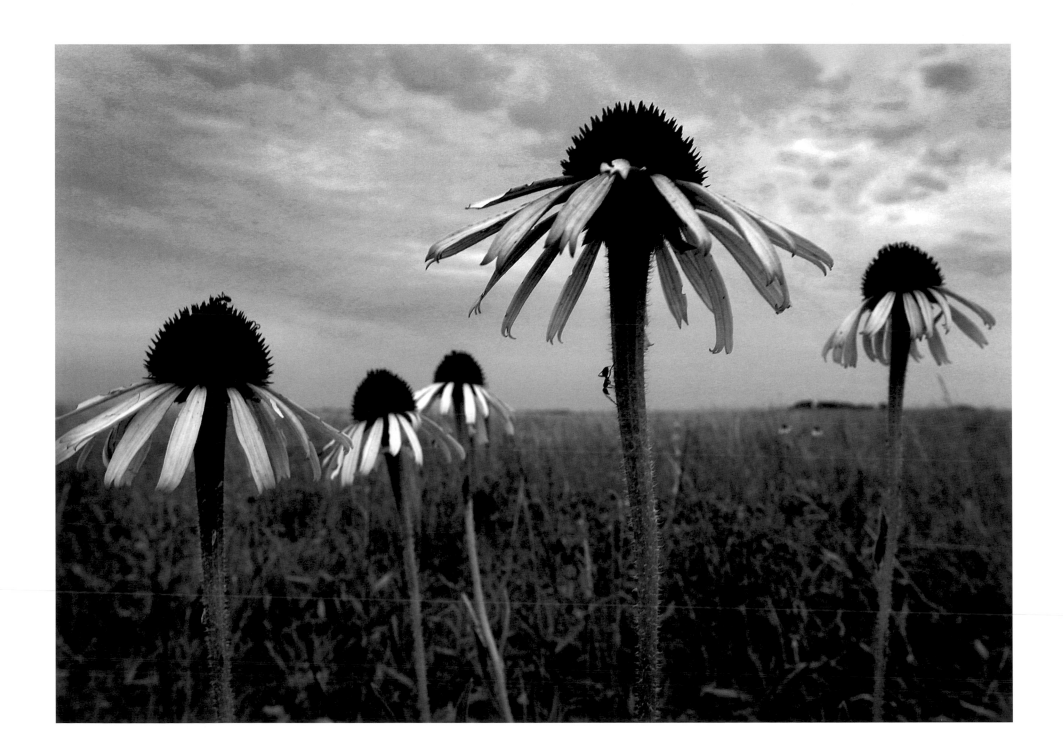

The Horizons of Reverend Cliff

FORREST JOHNSON

Two Harbors

FORREST JOHNSON
has held myriad occupations according to his fancy, at various times serving as a commercial fisherman, a logger, a member of a railroad track gang, a Forest Service technician, a mason, a crewmember at a canoe outfitting business, and the editor of a small-town newspaper. Beyond these varied jobs, he has always enjoyed writing. His story "Uncle Billy" was published in the *Permafrost Review* and won the Fejes Fiction Award. Forrest's connection to nature was made during deer camps and family canoe trips and by watching meteor showers with his grandmother, who taught him how to fish, how to whistle, and how to really see the natural world.

A SIGNIFICANT LINE OF HOUSES had crept within sight of Reverend Cliff's small wooden shack, which sat in a field roped off by surveyors' ribbons. Though he was ordained only by the local kids and a few farmers long since gone and professed no faith other than to "the Big One that looks over all life," as he put it, Reverend Cliff had always known it would only be a matter of time before nearby residents began to complain of the eyesore the crooked shack and its crooked steeple presented to them and their new lawns and cars and decks that overlooked his creek.

He had always understood that soon enough the town council and the mayor with the shiny hair and a developer or two would come by and explain with expediency that he and his nonexistent congregation should consider moving away.

On a homestead above the shore of Lake Superior, sculpted by lava flows and glaciers and the cutting of the pine, Cliff used to shake his head and admit he once held the notion that such intrusions would never invade his small corner of the world, where the ravens and grosbeaks had always been his only neighbors. He loved the birds and, at eighty-three years old, was shaped like a blue heron who lived on molasses-and-peanut-butter sandwiches.

As the houses grew closer and the roads continued to sever the countryside, Cliff said he tried to remember his field and woods before they had been hemmed in and made a skeleton of ribbons. But try as he might, he knew he couldn't bring back even in his mind what had been there before.

Upstream from Cliff's land, a small black spruce swamp had been logged and the creek bridged with fallen timber. A gravel pit had given up its marrow and sat abandoned, bleeding red clay into the creek with the slightest rain. Gates on nearby farmlands used to hold cattle in but now kept people out.

On quiet spring nights you could hear Reverend Cliff playing his accordion above the humming of the frogs and the buzzing of a few woodcock hoping to lure a mate. Even as once-remote lands were being swallowed by the toxic myth of manifest destiny, at Cliff's place you could still feel the morning sun rising and warming shoots of grass strong enough to push through the pavement.

Cliff would climb the six or so stairs into that small steeple and sit in a folding chair, his slight bent body hidden by an immense accordion. The lilting of the few chords he knew would repeat over and over, a mantra-like rhapsody that made your feet shuffle and seemed to push back the years and renew the land before your eyes. With the music, the new houses were gone. The creek flowed clean and the mayor with the shiny hair and his friends the developers were boys again who fished for brook trout and built tree forts and rode their bikes through the woods that they would never want to lose.

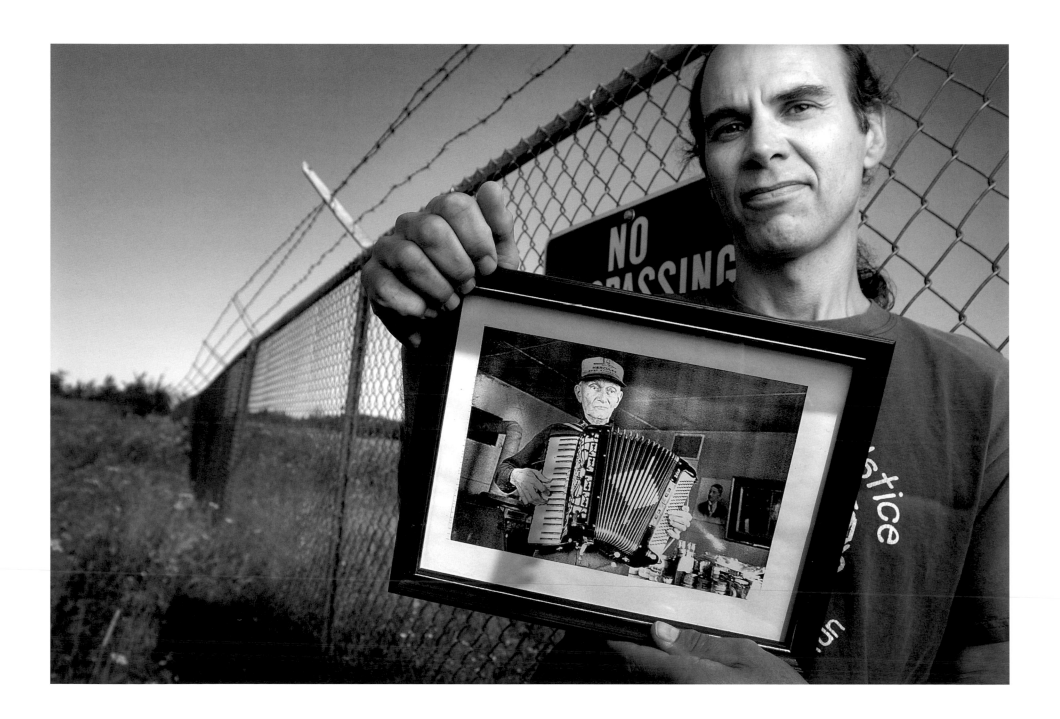

My Aunt's Farm
BRIAN CORNELIUS
Mankato

BRIAN CORNELIUS
is a high school student in Mankato with interests in football, baseball, martial arts, and music. His appreciation for nature began while deer hunting with his dad, as he enjoyed sitting on his deer stand and observing what went on around him. After graduating from high school he plans to attend a four-year college to study science.

I FEEL REASSURED knowing that there is always a place that I can go to when I need a break from life. When I am here, it seems like the whole world stops and I forget all of my troubles. I am very grateful for a place like this.

You can go to a place. You don't know that it will become very important to you. You just know that you want a place to get away from the world for a while so that you can think about things.

My place happens to be on my aunt's farm, which is about five miles south of Mankato. The place where I like to go is in the woods, where there are hills, many varieties of trees, ravines, and a creek. It is very comforting for me to breathe in the fresh country air of this land.

When I sit down by a tree I feel peaceful and completely relaxed. I hear squirrels chattering away, the soft whistle of the wind, and birds singing. In the fall the trees are alive with color. The leaves are every shade of red, yellow, and orange that you can imagine. In the spring the trees are alive with life, there are birds singing everywhere, and squirrels playing chase as if they don't have a care in the world.

I have known of this place ever since I was a little kid, but it has become more important to me as I have grown older. This land belonged to my great-grandpa and is where my mom grew up. I have been fortunate enough to see and learn from this land, and I hope that my kids will someday be able to also.

On this land I am able to hunt and hike wherever I want to. I like being able to come here to clear my mind and to escape from the world for a little while. After I do this, I am able to face the everyday challenges of life a little bit more easily.

Whenever I come here I am able to feel free, and because of this place I've gotten to know myself better.

Paradise
LEWANN SOTNAK
Aitkin

LEWANN SOTNAK
is a retired teacher who has lived in
northern Minnesota, Minneapolis,
Chicago, and Upper Michigan. She
has written a wide variety of educa-
tional material published by Win-
ston Press, Augsburg Fortress, and
Edcon Publishing Group, as well
as the book *Their Light Still Shines:
Inspiring Tales of Faith and Courage*.
Her love for the natural world began
during her earliest years at the
family lake home in northern Min-
nesota, where she roamed fields,
swamps, and woods and her par-
ents, grandparents, aunts, and
uncles passed along their profound
respect for the earth. Her mother
taught her about trees, flowers, and
birds. "Listen," she would say as
they sat by the lake, "the water
speaks to us."

*The author (left) and her sister,
Beatrice Martinson*

WE SET OFF FOR THE TAMARACK SWAMP, my sister and I,
looking like two scarecrows dressed in knee-high boots,
ragged shirts, old raincoats, and felt hats from a bygone era.
For more than 100 years family members have delighted in
our tamarack swamp, named "Paradise" by our ancestors.

Together, we walk with the wind in a misty drizzle until
we reach the woods. Raindrops glisten on ferns and wet
moss. Fallen logs are damp and dewy. We spot a porcupine
napping high overhead on an evergreen branch.

Squish, slurk, squish, slurk go our boots. We balance on
a mushroom-studded log that leads us across an oozy moat
that rings our five-acre swamp. We are in Paradise.

Fragrant tamarack trees stretch their lacy branches to-
ward springy sphagnum moss that carpets the ground.
Pitcher plants hold their vessels ready to catch the raindrops
and trap unsuspecting insects inside. Pink lady's slippers
and yellow moccasins stand coquettishly in deep moss.
Tiny tree toads, no bigger than pennies, leap away from
us. Stretched between tree boughs, delicate webs hold fat
spiders, waiting for dinner.

A giant black spruce lies victim to old age. Under its pro-
truding roots rests a baby fawn. The fawn looks at us with
soft brown eyes. Its mother must be watching nearby, per-
haps worried about our intentions. We coo to the fawn, then
continue on, stepping softly from one mossy hummock to
another.

A cluster of parasol-shaped mushrooms brings back
memories of times when our childish imaginations led us
to believe that this swampy world was inhabited by elves,
fairies, gnomes, dwarves, and perhaps a troll or two. In our
hall of memory, we can almost hear the elves laughing,
chattering, and arguing under their mushroom umbrellas.

We retrieve another memory as we view a tall, dead snag
sprinkled with large, hoof-shaped mushrooms. For us, these
were secret stables where dwarves carefully hid their horses
with only the hooves poking out. When there was trouble in
the forest, the dwarves mounted their steeds and galloped
off to settle fights between the gnomes and trolls.

Today, my sister and I worry that such wondrous worlds,
both real and imaginary, will vanish forever if Minnesota's
swamps and wetlands are regarded merely as mosquito-
infested wastelands to be drained, paved, or developed. Our
hope is that such vital ecological habitats will be preserved
so future generations may experience wonder and learning
as we did in our swamp, our Paradise.

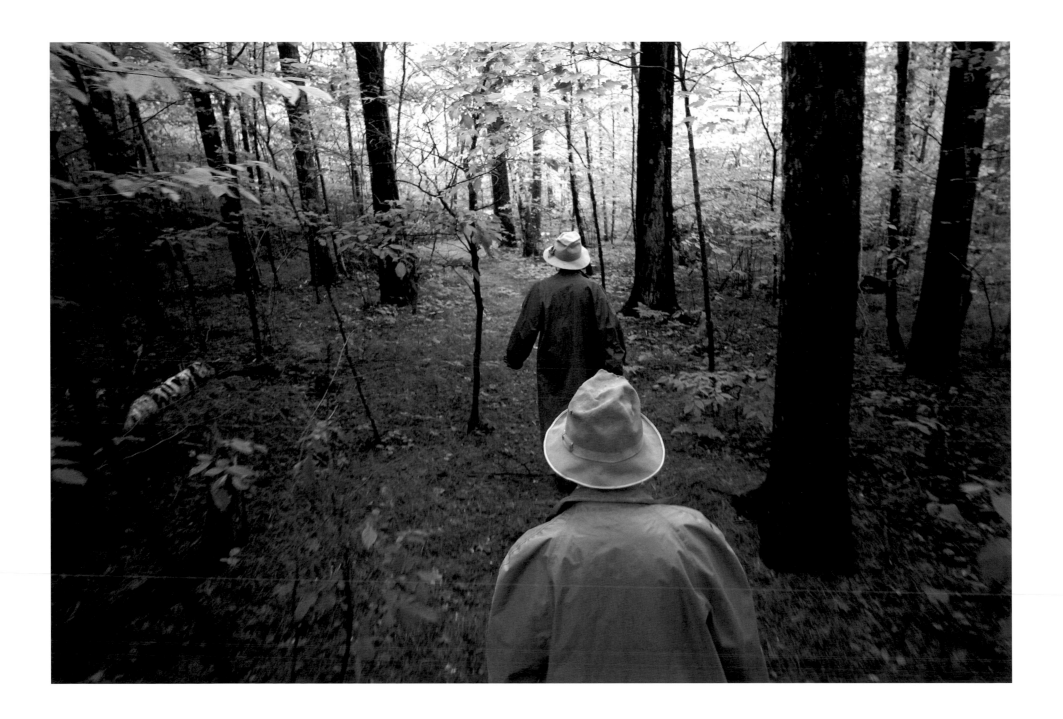

Summer

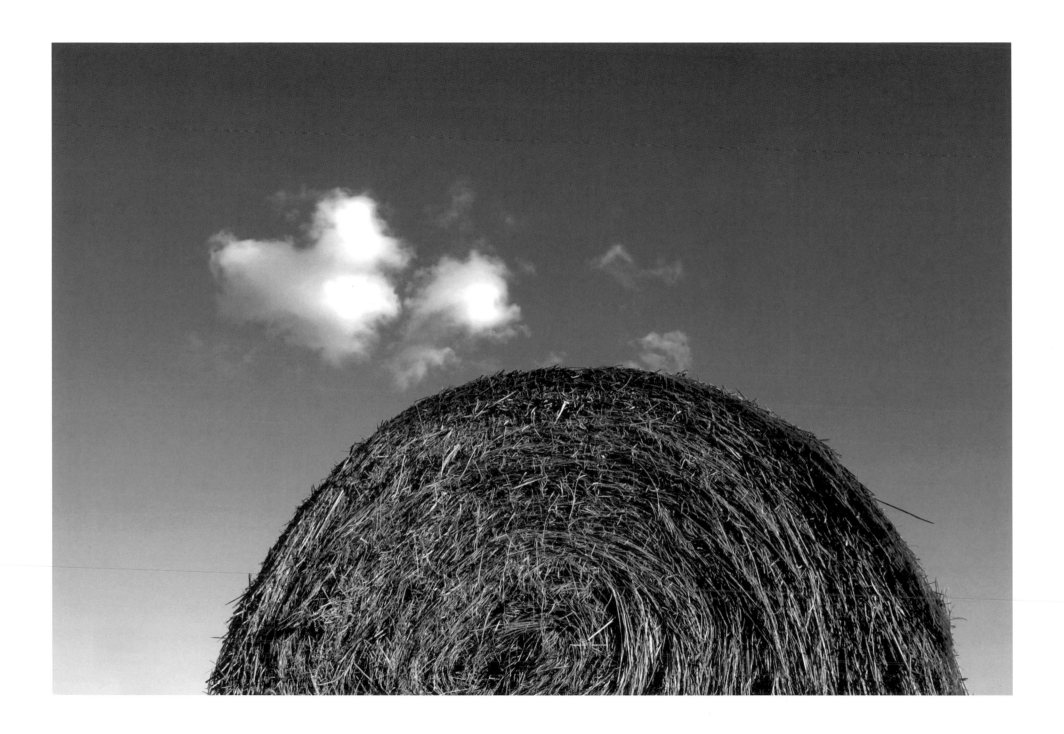

Tower Hill
JOHN HOLMQUIST
Prospect Park

JOHN HOLMQUIST
is a retired geological engineer who edits
the Voyageurs National Park Association
newsletter. His columns, essays, com-
ments, and stories have appeared in
newsletters and in the *St. Paul Pioneer
Press* and the Minneapolis *Star Tribune*.
His urban childhood was blessed with op-
portunities to ramble in forest and field,
though these remembered places are now
built up and paved over. He fondly de-
scribes one of these places: "three short
blocks down Cecil Street hill ran the Mis-
sissippi River. At the base of its steep bluff
the cityscape would disappear, and I'd
dream my way back to a time before white
Europeans canoed its upper reaches."

TOWER HILL IN PROSPECT PARK has, over time, felt the tread of countless feet. We can't know how it was originally called, but the first humans to stand there must have given it a name. As the highest in a set of hills near the Mississippi River gorge, rising out of prairie and oak savanna, it would have been for them a place to visit but not to live. A place for better vision: outward toward animals and other people, or inward, perhaps while fasting, to divine their individual paths.

My first time on Tower Hill is lost in a child's early memories. It would have been before I started kindergarten in Pratt School at the foot of the hill's long, steep west side. I didn't know then how lucky we all were that it was still there. Nineteenth-century developers, looking eastward from old St. Anthony, coveted Tower Hill for its gravel. They were fended off, and sixty years later the water tower itself—a Romanesque medieval neighborhood icon topped by a conical witch's-hat roof—barely escaped demolition.

In childhood, I ran through boundless urban wild lands imagining myself as a Dakota brave: from the Mississippi gorge to tall woods extending for blocks back from the river bluff, from acres of savanna circumscribed by railroad tracks to vacant lots large enough for our pickup ball games. Of that richness, only a tamed river gorge with asphalt paths and park benches remains. Buildings—and an intrusive Interstate Highway 94—fill the rest.

As an exploration geologist in the American west, I regularly moved through spaces so vast as to diminish me to a speck in the cosmos even while they folded me into the grand design. I have felt the same while walking the sky-wide tundra in a chill wind off Hudson Bay or on a shrouded path of tree roots through a Guatemalan cloud forest hung with bromeliads and thick vines. Now here I am, back home, tolling the worth of a humble scrap of land atop the highest hill in the city of Minneapolis.

We lament our lost amenities, but Tower Hill is there. It survives the errant vandal, the late-night reveler. It invites the pilgrim, picnics, lovers, weddings, worshipers in the sun's rising. And it spreads a sunset to conjure the day.

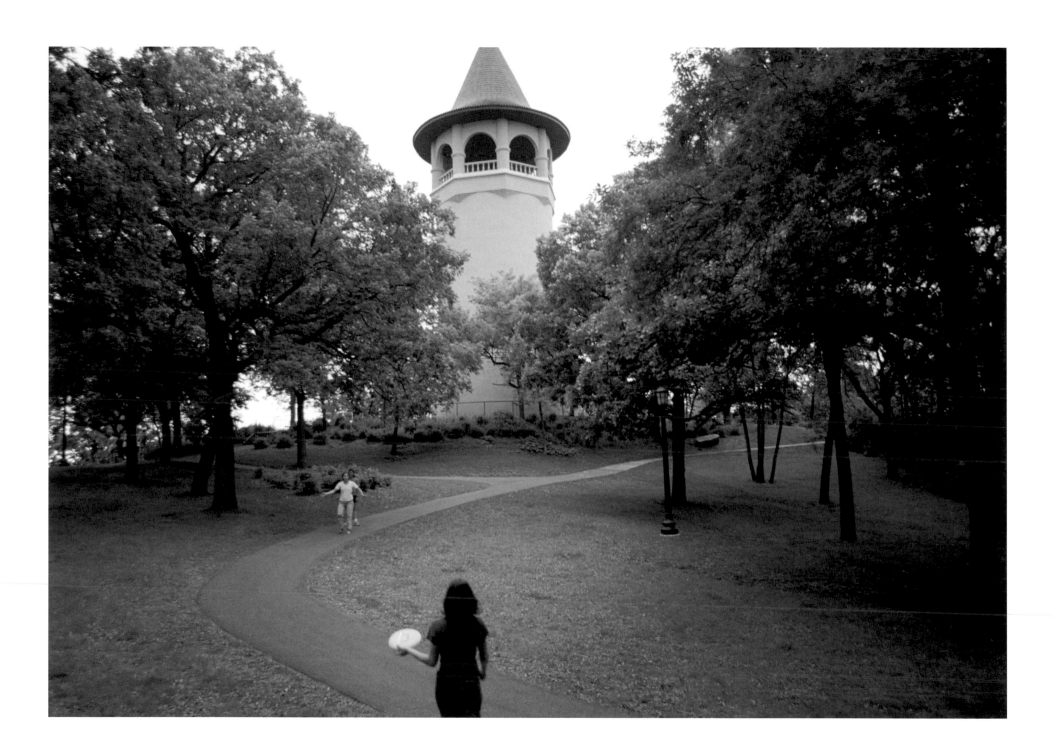

Camping Memories
THUY NGUYEN
Mississippi River

THUY NGUYEN
came to the United States from South
Vietnam in 1996 and now attends school
in St. Paul. Her work has been published
in *New Moon* (an international magazine
for girls) and through the Mindworks pro-
gram. She recalls the Vietnam countryside
and the natural surroundings that were a
large part of her childhood, describing
this period as "the best years of my life."

THE SUN WAS BIG AND HIGH in the blue Saturday sky. I lifted my head to catch the warm rays dancing on my hair and in my cousin's eyes. The smells of wood and flowers lingering in the air added to the peaceful atmosphere. We were on our way to our campsite on the Mississippi River, just a ten-minute drive from our house by the state capitol. Our silver boat was splashed and rocked from side to side by the strong current of this famous river.

Once we reached land, my cousins started to set up tents for the night while I ran around exploring the shore. The fine white sand felt like silk under my feet. Waves caressed my hands with gentle touches, and when they receded they left colorful rocks behind. They were all beautiful. The water was still and shone like a sheet of gold under the sun. The wind blew gently, just enough to lift my hair and then let it fall across my face.

As soon as the sun began to set, we made a fire on a clear patch of ground. It crackled loudly in the silence of the evening and sent sparks flying around like fireworks. The bug repellent seemed to make no difference to the mosquitoes, and even though their bites itched like crazy, no one was paying attention to them—the full moon had become the main attraction.

Under its magical cool rays everything was quiet. We could see the woods behind us, and a winding path that led into the woods looked like a road fairies might use. Before us the water was a smooth, sparkling, white-silver carpet I would never tire of watching. The silver rays seemed to coat everything inside and out with the moon's cool touch. Even the humming of the insects had become easy and gentle rather than the annoying buzz that had greeted us earlier. Perhaps the full moon changes everything into its most perfect form.

I will never forget the peace and beauty of the Mississippi River in the moonlight, and I will treasure the memory of my feelings that evening for many years to come.

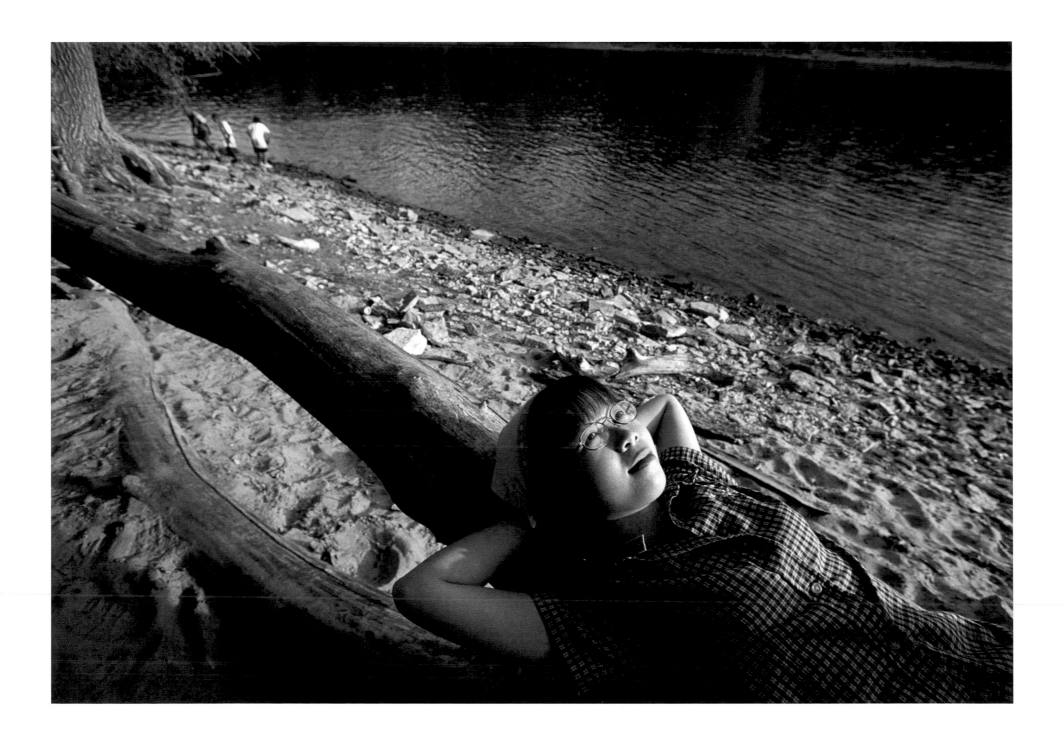

Urban Wildlife
MARGARET MILES
Minneapolis

MARGARET MILES
is a freelance writer who grew up
in St. Paul near Como Park, where
escapees from the zoo—mostly
of the winged variety—made occa-
sional visits to her back yard. She
remembers family vacations during
which her father, a professor of
forestry and an early advocate for
teaching ecology and conservation
in Minnesota's elementary schools,
would pull the car over to the side
of the road in the middle of no-
where and herd his seven children
out for a tree-identification lesson.
From his example she learned that
"wilderness isn't so much a place
on a map as a condition of the
heart" and that "one should never
take nature's gifts for granted,
even—especially—in one's own
back yard."

I LIVE IN THE HEART OF THE HEART OF THE CITY. The little twenty-by-thirty-foot plot of grass I own with my sweetheart supports a full flock of street-tough birds—sparrows, starlings, pigeons—a dozen squirrels, one rabbit, and the occasional species that migrate through like our neighbors in the apartment buildings. They stay just long enough for us to get to know them by sight, and then they're gone. We faithfully tend a birdbath and four feeders, even though I like to bellow daily in my best Ralph Kramden, "House and home, Alice! They're eating us out of house and home!" And then we refill the feeders.

I understand when people leave the city to "get back to nature." It is true that the freeway a block away drowns out all caws, chirps, and warbles and the blue TV glow in a dozen windows down the alley forms a constellation I can see far more clearly than the Big Dipper. And it is true that we recently learned that the lead content in the mini-brownfield that is our back yard means there will be no vegetable garden this summer. But still, nature lets me know it is here every second, relentlessly bursting through the seams in the sidewalk, storing nuts in the walls of my attic, leaving little blessings on my windshield.

I hope I live long enough to chart an atlas of my back yard. I'll chart a gazetteer of the tender undulations of the landscape from inch to inch, the moist rivulets that are the earthworm's world map. I'll write a romance novel depicting the passion of the maple for the wind and a dissertation on the wanderlust of the creeping charley.

I was raised to know that I am responsible for tending my yard, not just for myself and the neighborhood, but also for the bugs and beasts with whom I share it. My back yard is a tiny land trust, and I pronounce myself the honorary conservation officer for this little lot. As long as I'm here, the flock is safe, the mice will not be evicted from the garage, and the dandelions will never taste poison. I may even let the little lawn go to prairie, though it would surely incite the ire of my neighbors—seedlings of "weeds" flitting about as if they were wild. As if this were wilderness.

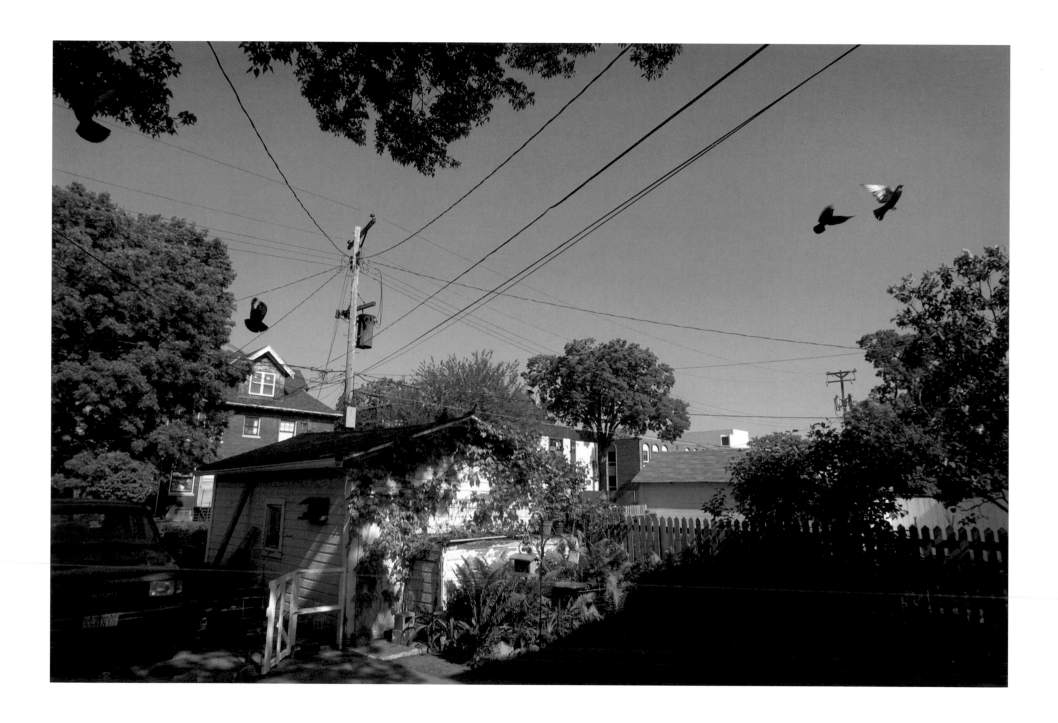

Mother Earth
CATHERINE DOEGE
Shakopee

CATHERINE DOEGE
grew up in rural Hennepin County,
with woods and fields around her house
and a lake nearby. She remembers walks
along the beach with her mother and
playing in the woods during summers,
and she attributes these activities to her
respect and appreciation for nature. To-
day, she enjoys nature walks and collect-
ing agates with her daughter, Sabrina.
She is pursuing a career in horticulture
and plans to continue with her writing.

AN AGATE IS A STONE. According to Webster's dictionary, it is "a striped or clouded piece of quartz." One hot August afternoon I discovered the ancient truth, or perhaps I should say I *rediscovered* the ancient truth about these stones. I say this because I believe my soul, my being, has known this truth for centuries. Maybe eons.

Not far from my house is a gravel quarry. Driving past, I thought what a wonderful place to run my dogs and soak in the sunshine. I pulled onto a dusty dirt road, which took me down a steep hill.

My two dogs took off immediately, noses to the ground. I stood there in awe of the stark beauty. The walls of this pit rose at least 200 feet above me on all sides. I looked up and was amazed that I could see in those walls the bands of time—layers of sand, boulders, and clay.

Those layers had not seen the light of day for perhaps one hundred thousand years. Not since the great glacier had deposited these stones and fine sand and then melted away. Not until the men came with their trucks and tractors, peeling back the earth. It was then that I eperienced a rush of feelings I couldn't describe, except to say it was almost as though I was being filled with a mad calm.

As I was thinking about this, I spied the most beautiful stone I had ever seen! Its perfect rings of red, white, blue,

and black mimicked the bands of the walls above but were a hundred times more beautiful. The stone was luminous, as if lit from within. I knew I was the only human to have ever set eyes on its beauty.

I also knew then that the flurry of feelings I had experienced were not my own, but the feelings of my mother, Earth. This stone was a gift. I was embarrassed, ashamed and saddened to be one of the creatures that was causing her such pain. At the same time, I felt her forgiveness.

Earth, like a mother, is productive, reproductive. We are born of the earth: humans, animals, trees, and stones. No matter how much pain we cause her, no matter how much we take from her, she loves us just the same.

But our mother is damaged, injured, weakened, and she is losing the power to heal herself, and with that goes her power to nurture us. If we turn our faces away, separate ourselves from the earth, never acknowledging that there may be no chance for healing, refusing to remember what we have done and what we have failed to do, then who can forgive us?

The agate I was given that day is a constant reminder of what I learned. Many times since that day, I have been driven to return to the quarries, to search for the elusive agate—my stone of hope.

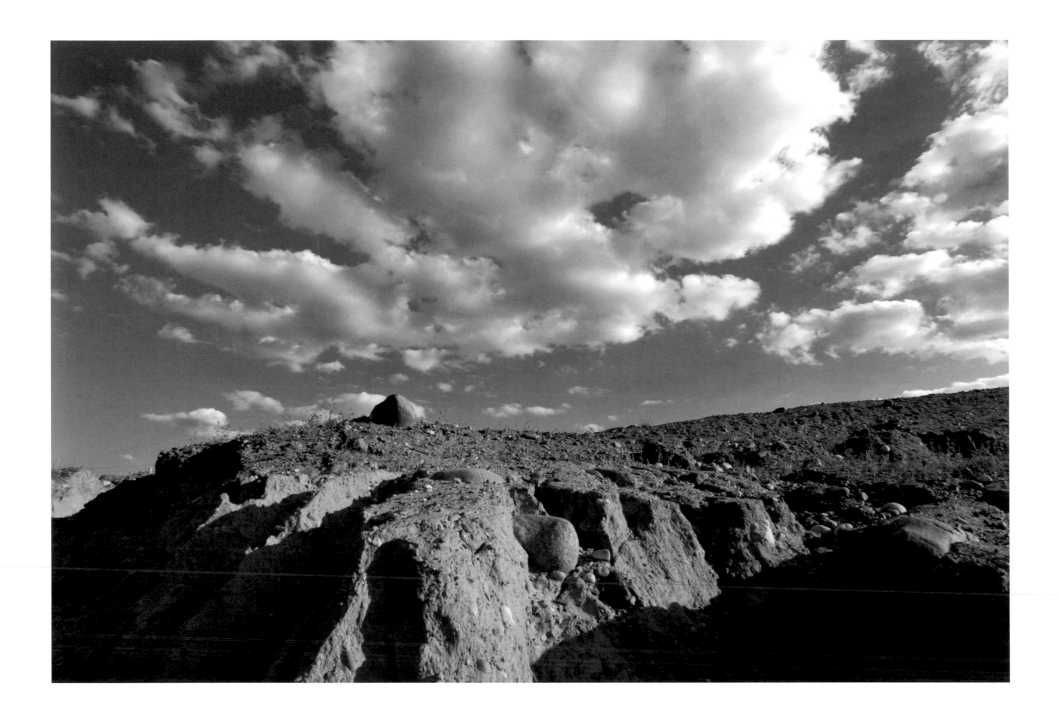

Big Woods Restoration
LAWRENCE MORGAN
Montgomery

LAWRENCE MORGAN
gained an early appreciation of the natural world in the woods of Minnehaha Park and along the Mississippi River as well as on the prairies of northeastern Nebraska's Winnebago/Sioux reservation, his father's birthplace. He has worked as an artist, a sign painter, and a cabinetmaker and has long been a student of forestry, botany, and the wilderness. He firmly believes that restoring the landscape to its past varying forms of wildness is the noblest human virtue and the ultimate work of art.

THE FORESTED PLACE WHERE I LIVE and that I share with myriad non-human sentient beings is part of what was once known as "the Big Woods." To early French explorers like Pierre Charles Le Sueur, for whom this county is named, this was a howling wilderness filled with wolves, bears, big cats, and, in summer, enormous numbers of exotic birds. In his journals of 1766, Jonathan Carver noted flocks of what he called parrots but which were probably the now-extinct Carolina parakeet.

Le Sueur County's forests of centuries-old hardwoods were descended from the Appalachians' ancient lineage of forests. Unlike Minnesota's, they had escaped the last glacial episodes, and over the next ten millenniums recolonized what was to be southern Minnesota. Some of this wildness is still here in the remnants of the primal forest, where stately oaks and basswoods scrape passing clouds with their outstretched upper limbs, having luckily escaped the Czech settlers' axes in the mid-nineteenth century.

My woods have been recovering from the domestic grazing animals that, year after year, devoured and trampled the wild and now rare plants that once graced the understory.

Some, like cranesbill, the ghostly Indian pipe, and bloodroot, Minnesota's native poppy, survived and are thriving again.

My restoration began twenty years ago with the re-establishment of the wild orchids, ginseng, ferns, and a dozen other beings once native here. The old farm fields are yielding to the ash, cedar, and oak, while the hundreds of pine and fir I have planted now lend the summer winds their sweet balsam fragrance. Tonight as the sunset colors the evening sky, wild turkeys roost in the tall trees where only five years ago there were none, and the owls and coyotes call and speak in languages long lost to the ears of the industrial people who now occupy their lands.

At present, 98.5 percent of Le Sueur County's forests are gone, most cleared decades ago for agriculture. But like many across the eastern United States that have survived, they await their fate, either to be saved and restored or to become merely a backdrop of shade trees for more trophy lawns in the new apocalyptic urbanism that leaves no room for the mystery of the other beings.

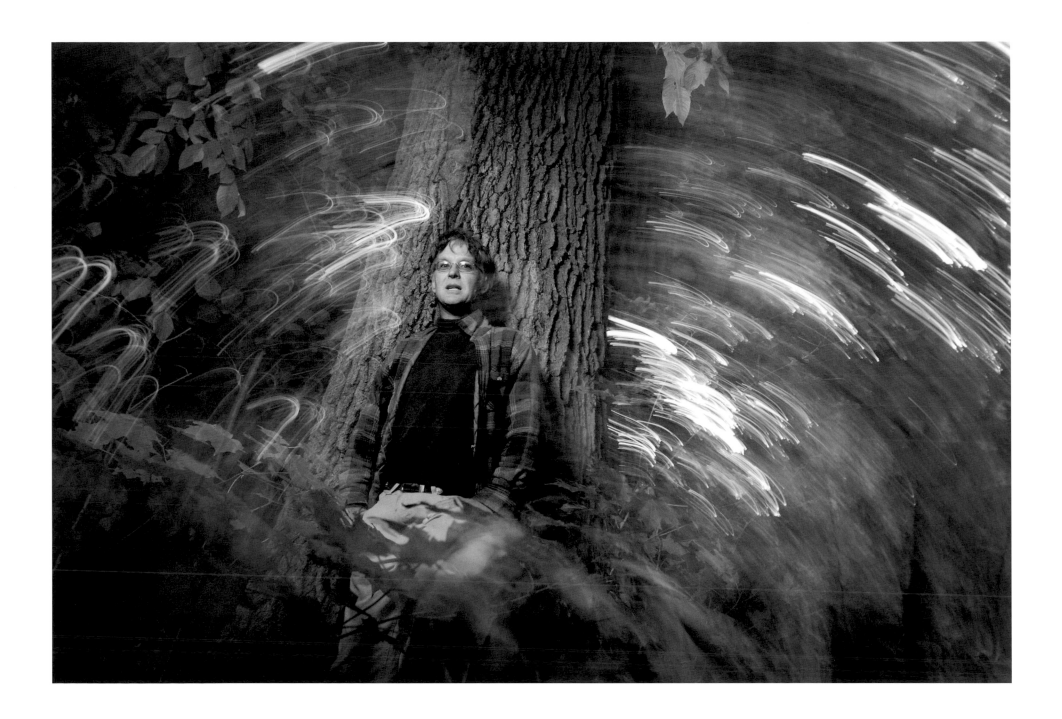

This Ground I Love
JANE L. TOLENO
Golden Valley

JANE L. TOLENO
is an independent education consultant. Her writing has appeared in *Dialogue: A World of Ideas for Visually Impaired People of All Ages, Palaestra: A Forum of Sport, Physical Education, and Recreation for Those with Disabilities* and *Angel Animals: Exploring Our Spiritual Connection with Animals.* She describes the power of nature throughout her life: "As a child who was blind, I trusted the authentic, direct connection between the earth and me. When I roller-skated, I tumbled down onto the ever-present ground. When I ran through Oregon weather, I discovered different kinds of rainy days. Throughout my life, I have been comforted because I could compare natural environments and seasons wherever I have lived."

The author and her current guide dog, Marko

OUR YARD SWING CREAKS as Fuller, my golden retriever dog guide, and I swing forward and back in the wind and the sun—back and forth from summer into fall.

My thoughts wander to changing seasons and settle on the ever-heavier sadness I feel in winter. Then, cold, newly sharpened or muffled sounds, and ice-coated and snow-blanketed landmarks slow my going, close me in, frustrate me or shut me down. Winter stirs my fears of immobility, inaction, and isolation.

Snow and fears melt when spring sunshine drenches me and my yard with light and warmth. I am freed again. A cardinal's two-note song, "Dee-Dah, Dee-Dah," teeter-totters me from long, hard winter into spring! This year, can I, like my yard, withstand winter, then nurture and flourish again? Can I synthesize enough growing season experiences, family and neighborhood gatherings, sensory memories, and less-arduous travel to sustain me during the coming winter?

Then, like a spotlight, summer sun bears down. Plants burst forth in bounty and profusion! Senses and perceptions alert, Fuller and I relish learning while exploring ash, birch, pine, and lilac, riots of wildflowers, sunflowers, annuals, and perennials, the green-smelling grass. Ripe strawberries and fresh-picked tomatoes taste full of sunshine and rain. Rabbit, raccoon, squirrel, and deer feed here.

Summer bees, mosquitoes, and other bugs hum everywhere. Raucous crows sell secrets blatantly. Chickadees and robins fuss but carry on nesting. Duck families quack and waddle by. Pheasants strut their stuff, squawking jibes, "You can't touch me!" Our driveway is their personal parade route. Evening cricket-calls ripple in my ears as I imagine northern lights shimmer before your eyes. Overhead, late-summer crowds of Canada geese blare urgent travel plans while keeping appointments in ancient space, on ancient paths.

Now, Fuller's cold nose nudges me into autumn and chases my reflective moods away. Sunshine, as gold as Fuller's coat, caresses me. Fall winds, warm and rough as cat tongues, carry loads of summer husks and crackling leaves. Sometimes, like jazz drummers with brushes and sticks, September winds snap branches or brush dry grass against us as we move. Moldering summer flavors and autumn fires mingle in this burnished September song. I listen and hear. My spirit sings as I share in the life of this Minnesota yard I love. I welcome spring, summer, and fall gifts. And, like my yard, today I make new peace with winter.

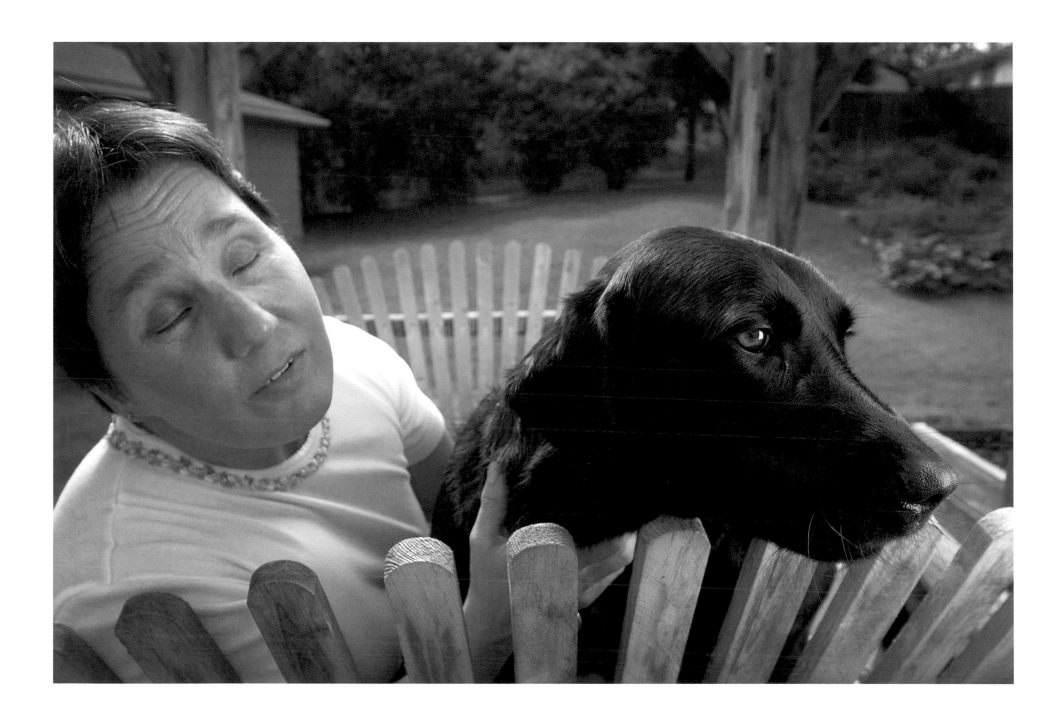

Love With a Root System
BECCA BRIN MANLOVE
Chapel Lake

BECCA BRIN MANLOVE
describes her introduction to nature's majesty: "First, I knew large skies and the subtle beauty of great expanses. When my family moved to Cloquet, I found the intimate charm of the woods. Later, standing on a frozen lake near Ely, I knew again a large sky, this time framed with the serration of pines and hung with curtains of northern lights. Nature has taught me that sometimes there is a moment of letting go and of finding a connection with That Which Is Greater." Her work has appeared in *The End of the Road Reader I* and *II* and in the *Ely Times*.

THERE ARE PLACES IN MINNESOTA THAT I SAY I LOVE, like the backwater at the bottom of Lower Basswood Falls and a place on Fairy Lake where the juniper grows. And I do love them, in the same way that I love people I don't know well. It's been fifteen years since I last visited these places, and yet I still can feel the delight and peace I found in each. But I believe there's another kind of love—a love that has developed a root system.

I live between Ely and the Boundary Waters Canoe Area Wilderness. Root systems don't just happen up here. Only 10,000 years ago, a glacier ground its way through our area and bulldozed most of the dirt ahead of it to the south, making life here more of a challenge for plants and their roots. It's taken the little tough ones, caribou moss and other lichen, to break the granite up into soil. The lichen produce acids that very slowly create precious centimeters of dirt. Some of them cling to the rock with microscopic rootlets, called rhizines. Lichens are patient, long-lived creatures that are willing to stay put through hard times, and they carpet one of my favorite spots in Minnesota, the overlook of Chapel Lake.

The overlook is a place of pine, lichen, and gigantic, steep stone steps that lead down to a body of water hardly big enough to call a lake. Sitting at the top, I am eye-level with the tips of white pines growing at the water's edge, still slender at the young age of sixty. Other pines grow on the narrow ledges and forest the top, except where the power line and the blacktop road cut through.

White pine roots don't focus their energy downward. Embracing the reality of the rock, they spill over the face of it. They celebrate each morsel of earth they find, spreading out in great abundance, intertwining with other roots. In the process, they hold soil and rotting needles in their arms—softening, changing the face of the rock itself.

In much the same way, I am shaped by the overlook of Chapel Lake. I've come here feeling angry, confused, impatient. If I sit still long enough, I find that the root system of love is very much alive. And it grows with gentle persistence within and all around me.

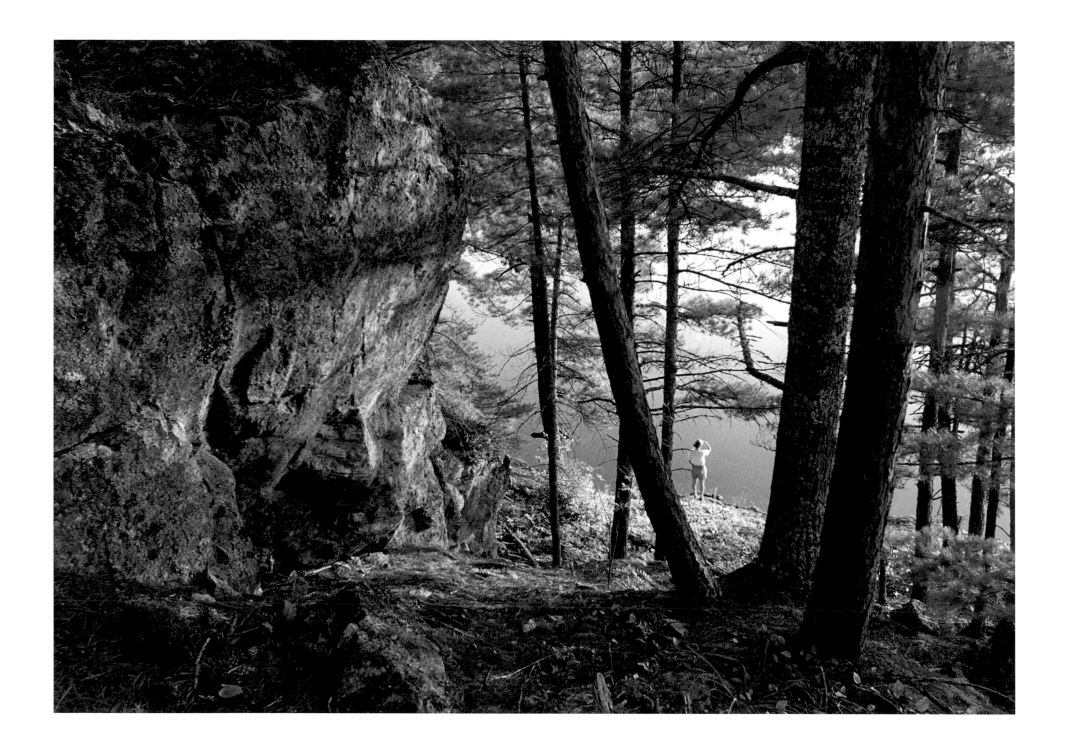

The Big Tree
LYNN LOKKEN
Lac qui Parle

LYNN LOKKEN
lives on her family's farm, which
was homesteaded in 1869 by her great-
grandfather. She grew up playing on the
prairie near the Lac qui Parle River. While
she recognized that her back yard was
pretty, she did not realize that those native
prairies and woodlands were rare, pre-
cious, and vital to our ecosystem: "It was
inconceivable to me that the river could
ever become too dirty to swim in or to eat
the fish." Only when the riparian woods
and native prairie hills were threatened by
a proposed road project did she grasp the
importance of what her family had been
cherishing and protecting for more than a
century. Lynn is the executive director of
Clean Up the River Environment (CURE),
a nonprofit grassroots organization that
focuses public awareness on the upper
Minnesota River and acts to restore the
river's water quality, biological integrity,
and natural beauty for the benefit of all.

WHEN I WAS YOUNG, my family would spend Sunday after-
noons going for a drive "around the lake"—Lac qui Parle
Lake. As a family, we'd hop into the car and begin winding
our way through the river valley. As we drove, we would look
for wildlife, ooh and aah over the beauty of nature, comment
on the fishing boats out on the lake, and wave at the neigh-
bors we met along the way.

On the east side of Lac qui Parle Lake was a sign and a
walking path to "The Big Tree." We'd park along the road,
open the gate, and begin climbing up the native prairie hill
on a mission to view the massive cottonwood. Following the
path carefully, avoiding poison ivy, mosquitoes, and wood
ticks, at last we'd touch the big tree, with its thick bark and
gnarly arms. Standing under its crown was awe-inspiring.
Of course, the trip was not complete until we tried to wrap
our arms around the tree. We asked our parents, "Is it two
trees grown together? How long will it live?"

The tree is said to be one of the largest cottonwoods in
Minnesota. It has been growing since 1860. A few years
ago, records indicated that the magnificent crown of the tree
was ninety feet across and that the massive base was thirty
feet in circumference.

The big tree sits at the bottom of a hill, near a small
creek. As I grew older, I would sit under the tree to relax. In
the fall, flocks consisting of thousands of geese would fly
over, creating a thunderous sound. My mind would wander
and I would wonder who has stood under the big tree and
waited for their best shot at a whitetail deer. Or I would
think of days when the Dakota hunted the area and what
this land must have looked like when my Scandinavian an-
cestors arrived to make their homes on the untamed tall
grass prairie.

In later years, I had the fortune to meet Lloyd, the man
who owned "The Big Tree." In his eighties and living in a
nursing home, Lloyd always welcomed visitors with a big grin
and a story. His family was so proud of that tree. As Lloyd
was no longer able to protect the tree, he was anxious to know
that someone else would look out for it in his absence.

"The Big Tree" is now protected and owned by the Lac
qui Parle Wildlife Refuge.

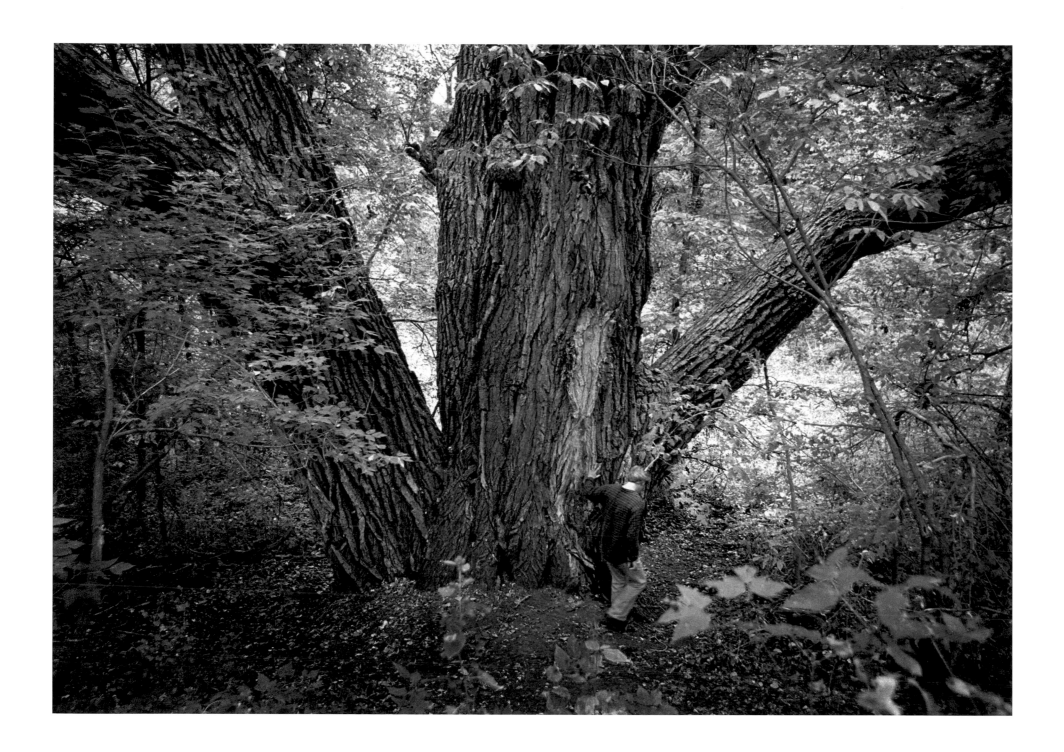

The Farm
KAYLEEN LARSON
Clarissa

KAYLEEN LARSON
writes part-time for a scientific
association based in Eagan. She
spent her teen years near the
central Minnesota town of
Clarissa and now lives east of
Brainerd. She credits her child-
hood on the farm with her deci-
sion to leave the Twin Cities and
return to a more rural lifestyle.
She has recently discovered the
joys of writing creatively, and
her work has appeared in the
Lake County Journal and on
KAXE radio in Grand Rapids.

FARMS ARE LIKE MARRIAGES: they require work, nurtur-
ing, and commitment. And they both tend to be overly
romanticized.

My stepfather was a farmer. He loved his farm like he
loved my mother. I understood neither. I was an eleven-year-
old aspiring gymnast at a Twin Cities junior high, and when
my mother announced that she was marrying my stepfather
and moving us to central Minnesota to live on a farm near
a town with no McDonald's, let alone a gymnastics team, I
was devastated.

On the farm I tried hard not to let the smell of fresh-cut
hay intoxicate me, or the softness of a newborn calf convince
me that this life was better than the one in the city I had left
behind. But nature has a way of drawing us in and soothing
our spirits, and it wasn't long before I, too, became a part of
the farm's daily rhythm, rising early to feed calves and help-
ing unload the last bale of hay as the sun set at the end of a
long, hot summer day.

By the time I left for college, my life in the city was a
faint memory. I could no longer imagine what it was like to
gaze on rows of houses instead of rows of corn. I wondered
if I would be able to see the stars through the city lights or
hear a thunderstorm over the noise. I realized that living on
the farm had changed me.

One late fall I returned. My stepfather was dying and,
knowing it wouldn't be long, he had pleaded to go home
from the hospital. He wanted to die on the farm. He and
I sat on the porch, watching the leaves blow in the October
wind. "Like them," he said, pointing to the swirling leaves,
"I don't have a choice about the direction I'm going."

We buried my stepfather in a small cemetery about a
mile from the farm. Nice, I thought. He would still be close
enough to hear the tractors moving along his acreage, to feel
the warm sun embrace his Fourth of July corn, and to watch
as soil from his back forty blew across his grave on a windy
April morning.

The more I think about it, farms are like life. There are
good years and bad years. And the good years make it all
worthwhile. I loved that farm like I loved my stepfather.
And now that I'm almost forty, I think I finally understand
them both.

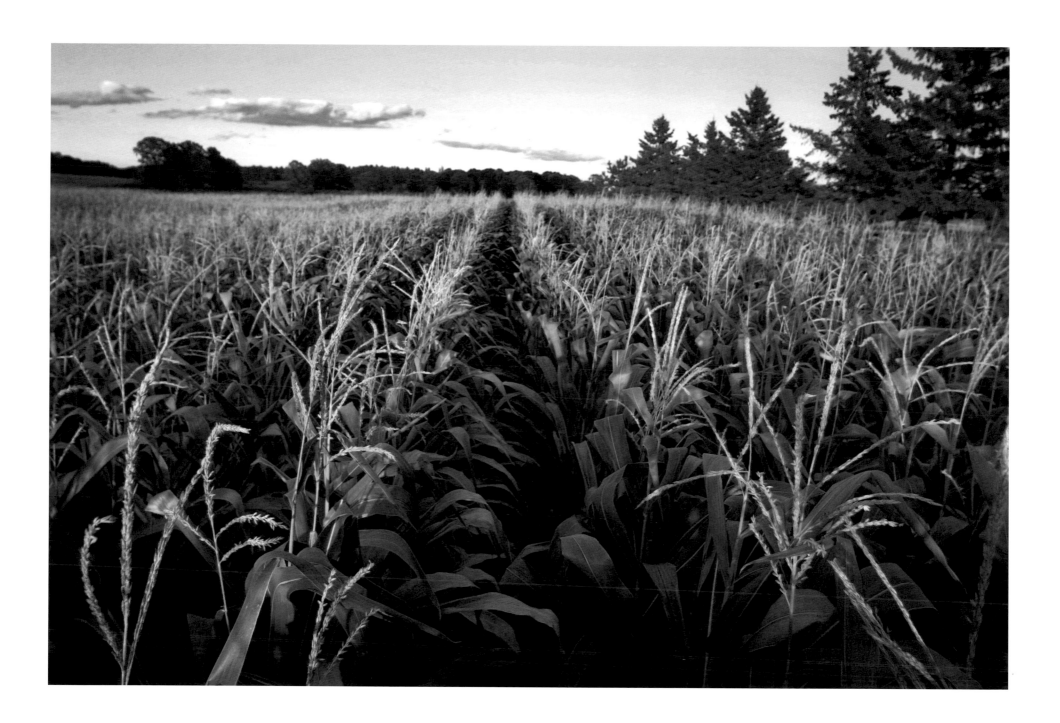

Hiawatha Oaks Preserve
PATRICIA ISAAK
Hopkins

PATRICIA ISAAK
came to love trees as she grew up in
Burlington, Iowa, a community with won-
derful parks and green spaces. She and
her husband, Vernon, and their children
have long planted, replanted, and gifted
trees. Similarly, writing has always been a
part of her life. A typesetter and desktop
publisher, she produces newsletters for
the Friends of the Hopkins Library and for
the Minnehaha Oaks Association, a non-
profit organization dedicated to preserving
green space. Her book *Helps for Leaders*
was published in 1978. She currently writes
guest columns for the *Hopkins Sun Sailor*
and is working on a book of tree stories.

THE TREES COME INTO VIEW as we travel east on Highway 7: a long, continuous span of majestic oaks, a canopy of green, beginning to change color at this writing.

I look at the forest for as long as possible. This process has been repeated many thousands of times in the forty years since our family moved to the area, when the trees covered a larger space.

Later, walking down the avenue, I look up at the huge trees. They adapt and endure, stronger as a group than standing alone, sharing space and light and moisture, devel-oping according to the surroundings and their unique quali-ties. Part of a tree may die but still serve as a wildlife refuge while a single limb continues to grow. Other trees and brush along the outer edges serve as protectors for this preserve, encouraging enjoyment from outside its boundaries.

I often think of the length of time it takes to grow a tall tree—a lifetime or more—and ponder the changes that have occurred in the decades during a lifetime. From horse and buggy to suv, pony express to e-mail, narrow dirt roads to multi-lane highways.

My favorite communication in this fast-paced world is still a letter. The following is a letter to the trees:

Some of you saw the turn of the century, and then the be-ginning of the new millennium. I wish you could tell your stories! You are a habitat for wildlife; you absorb rain and snow, provide cleaner air, and serve as a sound barrier. You give us beauty for all seasons. I admire your en-durance. You inspire me, you comfort me, and you give me serenity. Despite changes and progress, many of you remain. I will never take you for granted and will continue to work to preserve you, as a forest, for as long as I can.

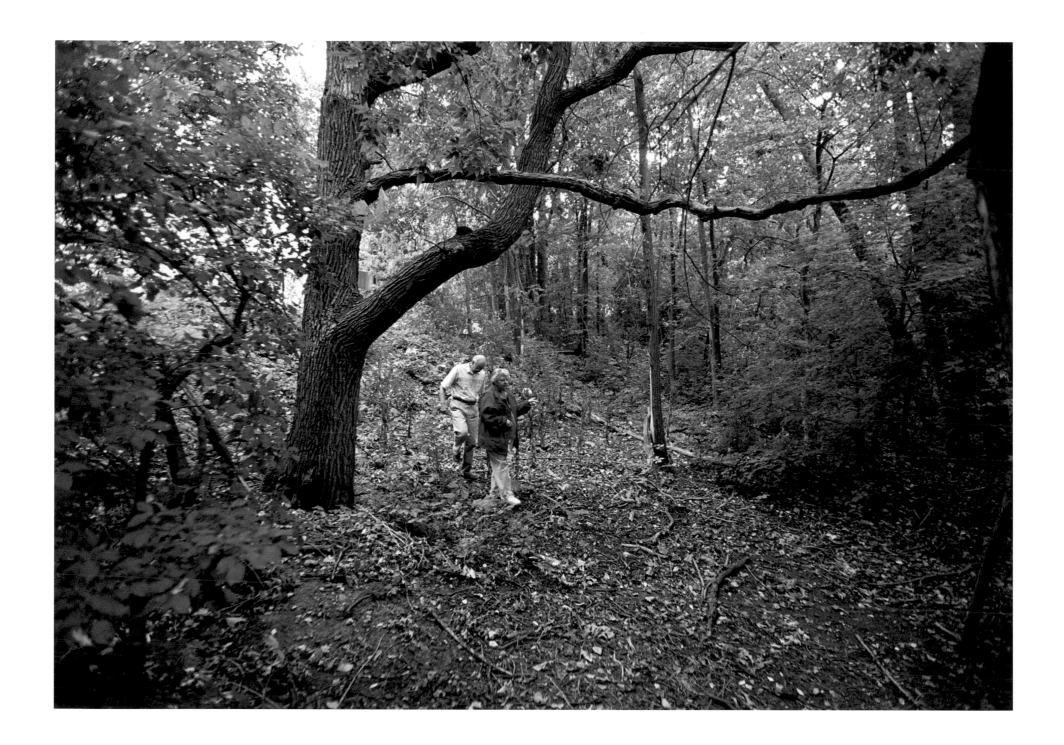

My Lost Paradise
MAI NGUYEN HASELMAN
Minnetonka

MAI NGUYEN HASELMAN
wrote this essay in memory of her
father, whom she considers to be her
biggest hero and who passed away after
a battle with lymphoma cancer. She and
her family immigrated to America from
Saigon, Vietnam, when she was sixteen.
The journey itself was hard, but it was
even more difficult to start over with
what little they had. Her father's strong
determination helped them to build a
new life. Mai is the proud mother of two
and currently lives with her family in
Lino Lakes, where she cultivates a
prairie garden and a vegetable garden
using seeds from her father's back yard.

I GREW UP IN A BEAUTIFUL HOME NOT FAR FROM SAIGON. It wasn't a castle, or even a huge house, yet to me that house my dad designed and helped build was my little paradise. It was surrounded by tall walls with tiny sparkling stones to protect us from the outside world. My brothers and sister and I couldn't wait to get home after school every day so we could play with each other. We invented fairy-tale stories, and there were always enough of us to have a queen, a king, a prince, a princess, and even a little soldier.

My father believed that home is not home until you bring nature in as much as possible, and with that in mind he transformed a small area around the walls into a garden with lush green trees and gorgeous blooming tropical flowers of a variety of colors. We played all day long under the shade trees, climbed up and played hide-and-seek under the mangos, rolled around on the soft green grass, which we had driven for hours out of Saigon to find and bring back. We ran under the hottest sun and—during the monsoon season—danced in the longest cold rains in Asia. At night we would sit under the bright full moon and bathe ourselves in the beautiful aroma of lovely white camellias. Life was innocent as a baby's first smile. War was never a real word in our vocabulary.

Within a few years after the fall of Saigon, somehow we got settled in Minnesota. To us, June was too cool without a sweater and January was unbearable. I cried myself to sleep for the first several months and dreamed of flying back to our homeland to dance again in our little paradise. Slowly, we learned to adapt to our new life. We were like tiny seeds that someone brought back from a trip overseas and buried deep down in the rich new soil. My father showed us how to reach high and open ourselves to let the sun shine in: we would not have survived if he hadn't.

He worked days and nights to give us another home, a small piece of land in Minnetonka. Time flew by, and before we knew it my father had slowly transformed the area surrounding our new house into a beautiful garden. In the summer, we would gather in the back yard, our own children sitting on the lush green grass or running around to touch and smell the lovely flowers. We watched the blue sky framed by the deep walls of tall evergreen he'd planted years ago and ate the sweet plums picked fresh right off the tree. The smell of grape leaves on the grill blended with sweet corn to fill the air with love. Somehow, watching our children rolling around in the grass and running up and down the hill under an old maple tree took me back to the little queen, king, prince, and princess playing in that forgotten paradise. Memories came and went like the gentle breezes. My father sat quietly, watching us under a shade tree with a look of great happiness on his face.

He passed away a few months ago, and we had to wait until a mountain of white snow thawed before we could go back and dream in his lovely garden. We saw rainbows appear in the coldest time in December just following his funeral. The intense colors of those rainbows were somehow like the flowers surrounding his home.

Whenever I miss him now, I do not have to travel over the ocean, back to our beautiful childhood, into our little paradise in Vietnam. My mind has only to go back to those summer days in Minnetonka, when we sat quietly under that old shady maple tree and watched the blue sky. He and I sat together like that for many days of the last summer of his life, both of us taking our surroundings into our hearts as much as possible, knowing that yet again our small world would soon never be the same.

What my father gave us was not some expensive gift that you can put in a box and gift wrap; rather, he gave us a life's dream with years of hard work and passion to recreate what we had lost long ago. And there it remains, our little paradise, safe forever in my heart. And this time, nobody can ever take it away from me.

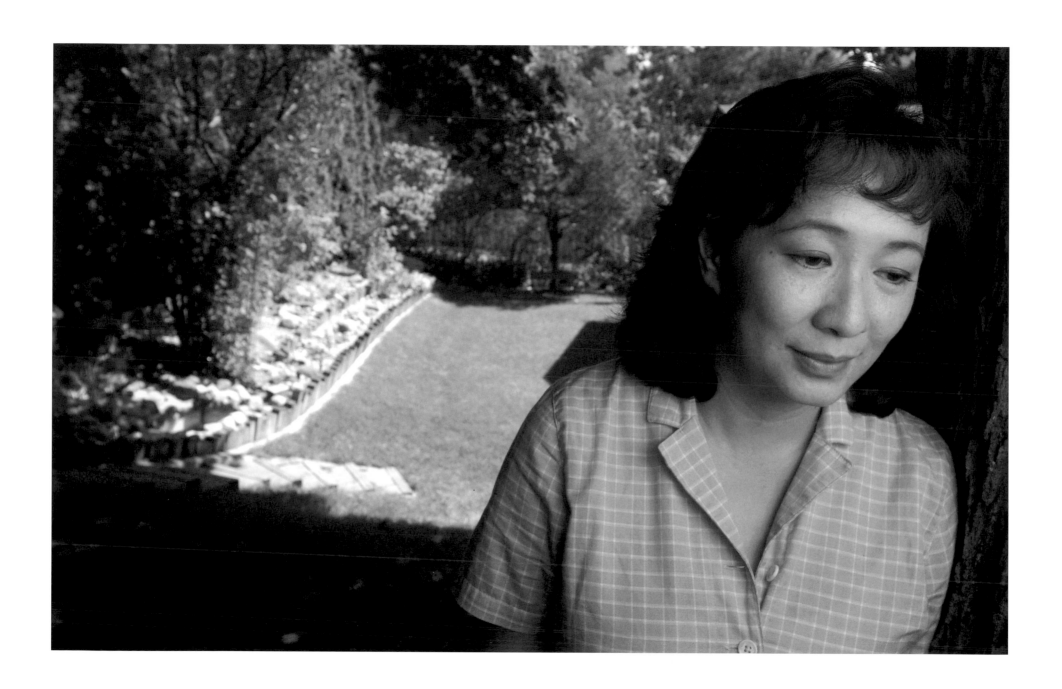

In Passing
PETER PIERSON
St. Louis County

PETER PIERSON
lives on the Whiteface River in
rural Cotton, where he is often
kept awake at night by saw-
whet owls and duets between
his Siberian huskies and nearby
wolves. He works as a paramedic
for a small town/rural advanced
life support ambulance service in
northern Minnesota and as a
Unitarian lay minister, serving
congregations in Cook and
Virginia. His essays have been
heard on KAXE, Northern Com-
munity Radio, and featured in
RealGood Words, *The End of the
Road Reader II*, the *Minneapolis
Tribune*, *The Northland Reader*,
and climbing magazines *Vertical
Jones* and *The Climbing Art*.

I DROVE WEST ONE HOT SUMMER EVENING on County Road 133, a determinedly straight ribbon of asphalt through the bog and hay country of central St. Louis County in northeast Minnesota. The sun was low, pausing, as it seems to do in midsummer, to alight on the western treeline before setting into dusk. A tractor crawled toward me, the driver taking on the same dusty hue as the horizon.

I stopped to let the tractor pass. Its rhythmic chugging sound grew, then faded. A mailbox stood on the side of the road, rusted and worn, hanging from one unbroken chain. An overgrown drive led to a cluster of spruce. Beyond, I could make out an abandoned home, its roof falling in on the west.

I got out of my truck and, checking on the tractor's progress, walked the 200 feet to the home. A rusted pickup leaned on blocks and one wheel in what used to be the yard. Through a broken window, I saw a table tipped onto the kitchen floor. An unbroken glass sat on a rotted counter.

As I walked back to the road, a small flock of birds flew toward me from the northwest. Against the bright sky, their size and shape and the broad strokes of their wings indicated that they were black-billed magpies.

These magpies are something of an enigma. The only place they inhabit outside of the western plains is here, just a half-hour's drive from the cold waters and Atlantic-bound freighters of Duluth's harbor.

Cleared by optimistic farmers, this land takes on the sentiment of prairie, resembling home to the magpies. But the birds have never grown in number from these isolated small flocks. I see them along the arbitrary boundary between the townships of Kelsey, on the west, and Cotton, to the east. They fly always just west of that line. As if they sense the breezes coming off the big lake, Superior, they know this is the limit to their place.

This is harsh country. Despite the efforts of Finn and Swede farmers, cold rocky soil and simple economics drove most to other jobs by day, then to the cities for good. Some just left, leaving partially fixed trucks in the yard and half-full glasses along the kitchen sink.

I watched as the magpies descended into a row of spruce and cottonwoods and then, one by one, took off, flying east again toward the tractor heading home.

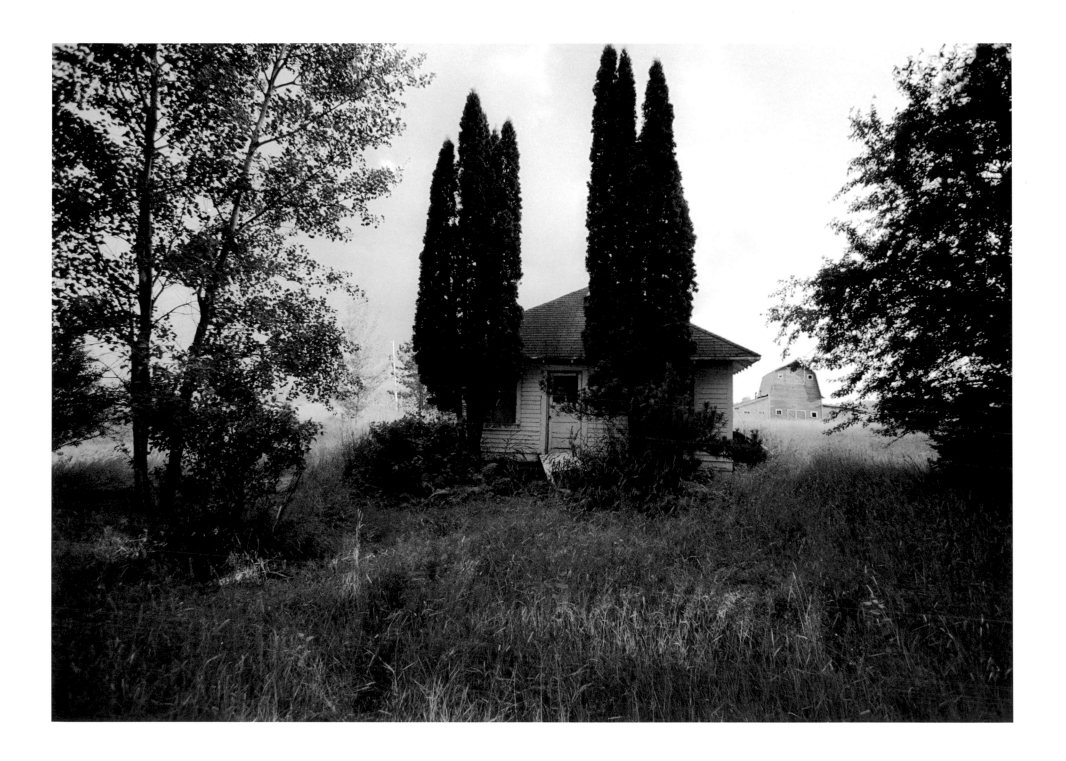

Fall

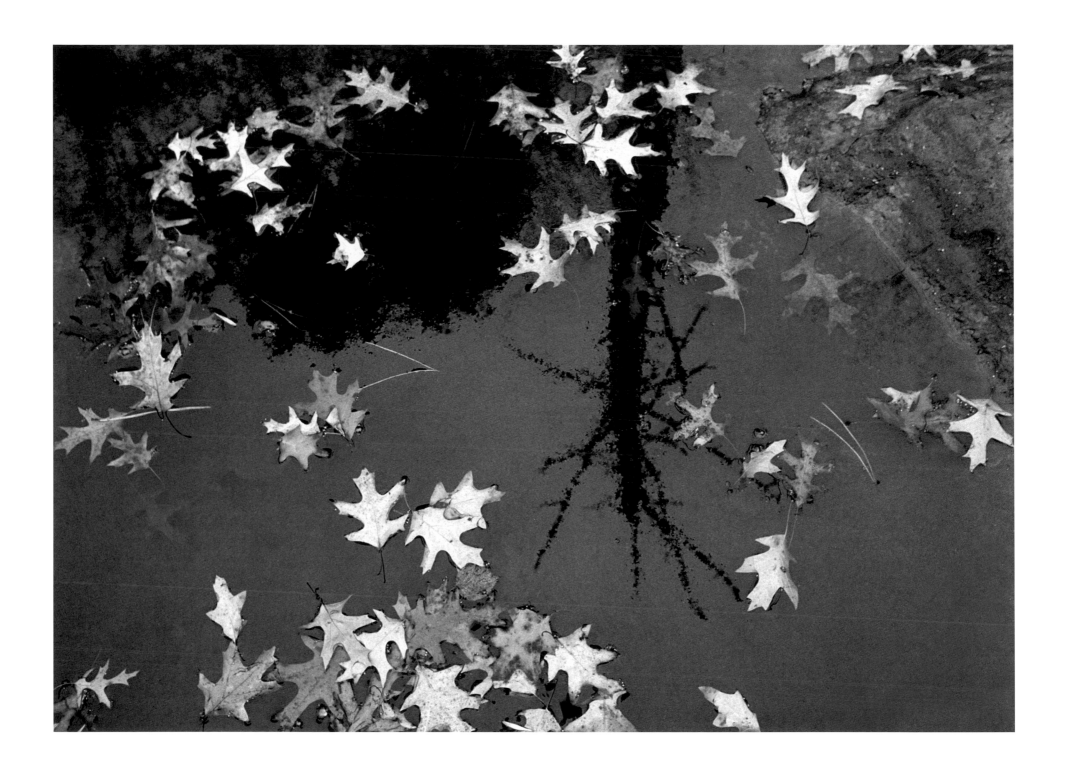

One of the Last
JESSYCA DUERR
St. Michael

JESSYCA DUERR
grew up in St. Michael and now studies
business at Arizona State University.
She has enjoyed writing since age ten
and is currently at work on two short
novels. A childhood surrounded by
lakes and trees inspired in her a deep
appreciation of nature, and she com-
pares her surroundings in the south-
west to her knowledge of Minnesota's
treasures: "While the desert valley of
Phoenix has its own harsh beauty, I still
hold that there is a profound peace of
the soul to be found in the forest. There
is no better place to clear the mind."

IN THE MIDST OF GREEN CORNFIELDS that span to an even greener forest, a house stands with its own mock woods hiding it from the view of passers-by on the road. A long, winding gravel driveway is the only evidence of its presence. Home.

Seventeen summers I have read under the shade of a maple tree and run through sprinklers, living off little but raspberries, water, and sunlight. Seventeen autumns, clad in a sweater and worn blue jeans, I jumped into piles of leaves a multitude of colors and carved pumpkins on the porch, listening to the dried, now-yellow stalks of corn rustle stiffly in the breeze. Seventeen winters, a hot cup of cocoa in hand, I reveled in the scent of pine needles thick on the ground around the house as I stared into the pure, still silence of the night. The moon glistened off the snow, eerie and beautiful; the forest loomed beyond the barren field. Seventeen springs meant endless days exploring the budding forest, watching thunderstorms until the wee hours of the morning, and dancing in the rain.

And now I stand on my property's edge, but, rather than looking across tall stalks of corn, I have to peer through a maze of bulldozers and model houses to see the precious forest that was home to so many of my childhood escapades. A glance over my shoulder would prove nothing, for I know what I'll see—I am surrounded.

The wind hits my face, and I both taste and smell the coming of autumn. Soon, there will be autumns here that I won't see. I'll come back from places far from my Minnesota, and this haven will be enclosed not by the beauty of nature that I've known but by the brick and siding I am learning to hate. I sigh, and the breeze echoes. At least for me there was corn to hide in, trees to climb, and streams to read by. At least I could grow up knowing these things. But this is a selfish thought, because I am one of the last.

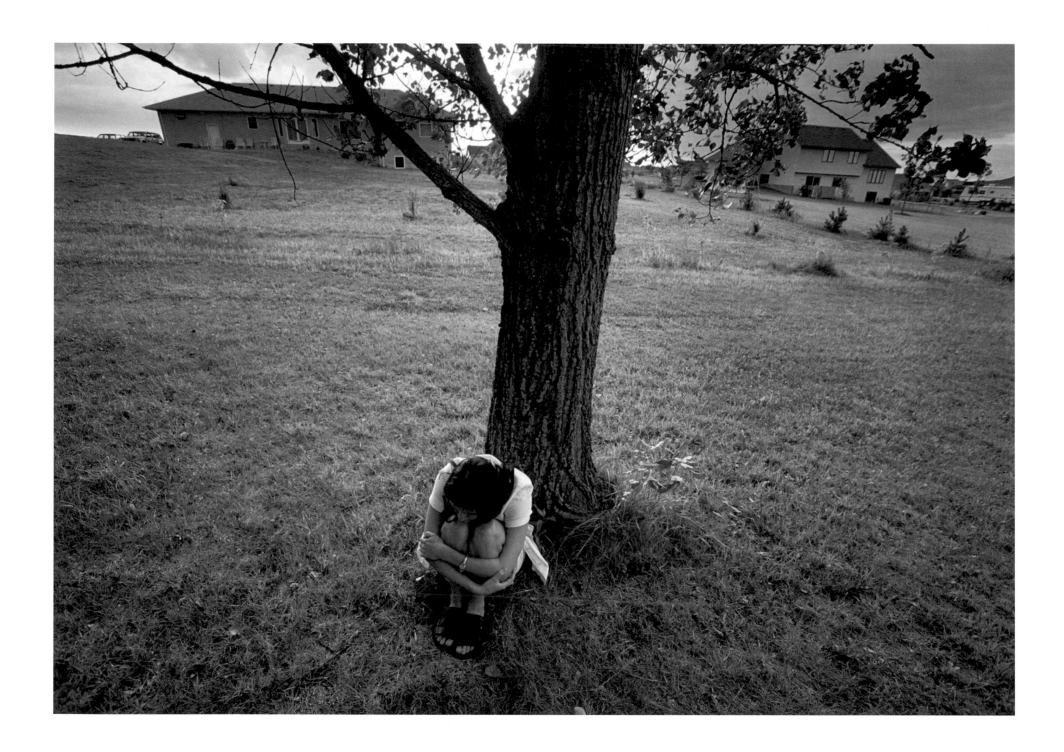

Rasmussen Woods
MICAELA BROWN
Mankato

MICAELA BROWN
attends high school in Mankato, where she enjoys acting, reading, writing, and drawing. She has always appreciated nature and considers herself lucky to have grown up in a town where nature is all around. She treasures Rasmussen Woods, and she is glad that it has been preserved as a place for everyone to enjoy.

I HAVE BEEN TO MANY AMAZING PLACES to enjoy the outdoors, but the one that comes to mind most often is Rasmussen Woods. It's a little natural area we have right here in the city of Mankato for all to enjoy.

On top of a hill near where I live is a grassy plain that slopes down into the woods. My friend Katri and I often go up there and sit in the shade to do homework together; it's not so boring that way. If we don't have homework or just don't feel like working on it, we run around doing cartwheels, racing, or just goofing off. Every so often I go up there by myself and sit and enjoy the peace and quiet. It's very relaxing, especially if your house does not fit that description.

To get to another one of my favorite spots in Rasmussen Woods, we follow along a bike path over a bridge, then climb down the steep bank on the other side where we come to a marshy area. There is a boardwalk that leads over the soggy ground through the beautiful marsh. Katri and I go down there sometimes and take off our shoes and socks and play in the mud. It is best to do this after a soft rain so it is nice and gooey. If you try it after a hard rain, you will sink so far down you could get stuck. If the mud is dry, we might play up on the boardwalk. Sometimes when we cross over a section of water, we rock back and forth and pretend we are surfing.

I think I'm very lucky to have a spot like this to go to with someone who I can really connect with. This experience may not seem very exciting, but in a place like Rasmussen Woods, the little things are what count.

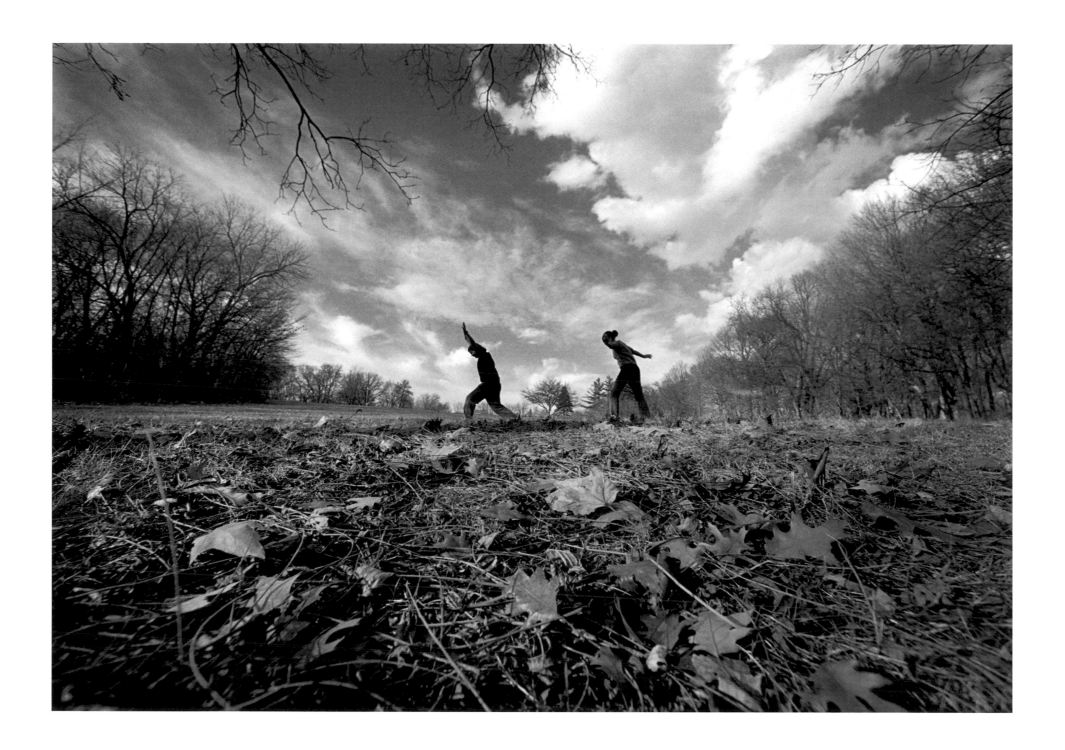

The Island of Pheasants on the West Eighty
BILL HOLM
Minneota

BILL HOLM grew up on a farm in Swede Prairie Township in Yellow Medicine County. He teaches at Southwest State University and has also taught in Iceland, China, and Madagascar. A poet and essayist, he has published nine books, most recently *Eccentric Islands*. He now spends a third of each year living in Hofsós on the north coast of Iceland, about thirty miles north of the Arctic Circle. There it is heat and mosquito-free and the sun does not set for two-and-a-half months, trees are few and views are long and spacious, and salt water breathes noisily and moves in the wind. He also enjoys the prairies for their treelessness, emptiness, long vistas, and wind noise.

A young Bill Holm with his father, Bill Sr., and mother, Jona

I LIVE IN AN ARMED HOUSE, AFTER A FASHION. My father's now almost-century-old guns stand upstairs in the corner of a spare bedroom: an 1897 Winchester 12-gauge pump and a Remington 12-gauge double barrel. I was a poor student of marksmanship as a boy, and birds were generally safe from my nearsighted inattentiveness. I preferred imagining pheasants roasting in cream to wings whirring into the autumn sun, the shotgun's boom, the happy Labrador scurrying off to bring back dinner.

My father didn't have to travel far to shoot the pheasants that he too loved so much to eat. I suspect that in the '30s, just before my birth, he didn't pay much attention to such niceties as a license or a bag limit. As he often reminded me, he and my mother, Jona, were so broke that all winter they had to eat the pheasants she canned. His favorite pheasant-harvesting grounds were on his own farm, a quarter-mile east of his house, on the West Eighty, as he called it. The Holm farm, bought by my grandfather from the railroad in 1885, sat on a hilly section of northern tall grass prairie, dotted with swampy unfarmable wetlands and stony thin-soiled pasture. There was a little good land, too—maybe half of Bill Holm's 280 acres, enough for him. On the wetlands grew heavy brush, willows, box elders, a cottonwood or two, a narrow strip of wilderness between two cornfields. Until the '60s, farmers left their corn stubble all winter and plowed in spring so the rich cover of the watery bottomland was always surrounded by an equally rich pheasant larder. Bill Holm Sr. shot many a bird from his tractor seat. His current Labrador—he owned a long succession of them, all named Peggy—would bring him the bird, its ring neck clamped in her powerful jaws. She waited, tail thrashing joyfully, till my father scratched her ears and fed her a sugar lump out of his overalls pocket; only then was he free to deposit the night's dinner in the tractor's toolbox.

In this lovely prolonged Minnesota autumn in 1999, I thought fondly of those hunting days almost a half-century ago: old men (about my current age) in tan clothes with bloody pockets walking through that brush with their heavy guns, their dogs busy scaring up birds. That strip of swampy brush ranks high among my list of magical places on this planet, but it exists now, unfortunately, only in memory.

Greed, madness, fashionable good intention—take your pick—overwhelmed the rural Midwest in the '50s. With the encouragement of "experts" and government agencies, farmers drained and ditched their sloughs and wetlands, plowed up the cattails, burned the willows in order to increase the tillable acres on places like Bill Holm's West Eighty. No more corn stubble to hold the winter snow in place, no more living and eating space for pheasants, now thinned out here but flourishing still in unditched South Dakota.

What did we gain? A few more bushels, a massive debt, lost topsoil, black snow, a ruined countryside—at least for providing beauty, pleasure, and pheasants roasted in cream. Jim Heynen, an Iowa farm boy and pheasant fancier, wrote a little prose poem called "Progress" in which the wise old grandfather, as he watches his wetlands disappear under the chewing jaws of the power shovel, says, "Something is going too fast nowadays. I'm not sure there was enough misery in that slough to plow it up." Maybe the real misery lives in the black ditch. Maybe we should drop a pheasant feather into it now and then as an apology to the gods.

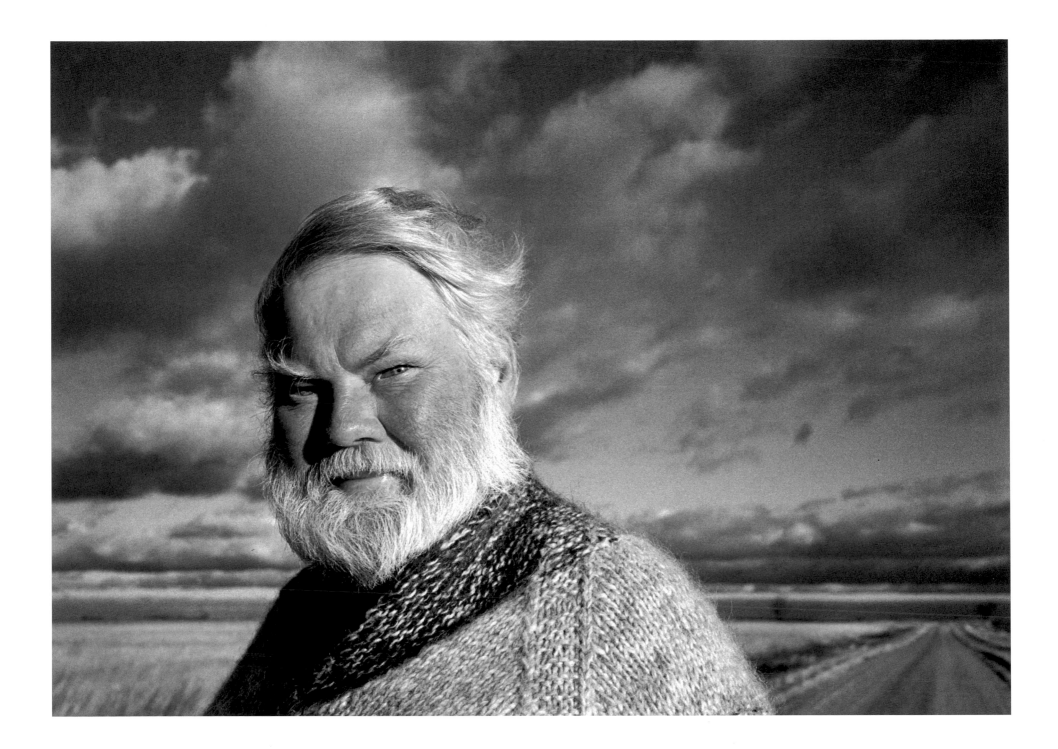

City Rituals
GRETA CUNNINGHAM
Twin Cities

GRETA CUNNINGHAM
is a newscaster at Minnesota Public
Radio, where she has worked since 1991.
An award-winning radio producer, she
also teaches news writing and reporting
at the University of Minnesota. She re-
ceived her undergraduate degree from
Boston University and is currently pur-
suing an advanced degree at the Univer-
sity of Minnesota. Greta is the books
and authors coordinator for Minnesota
Public Radio and is a frequent national
speaker on publishing, authors, and
readers. She grew up in New York and
came to appreciate nature as she ex-
plored the beauty of Long Island Sound.

NO ONE HAS EVER DESCRIBED ME AS A NATURE LOVER. I've often joked that as a child growing up on Long Island, N.Y., I thought that a nature outing consisted of flipping through the latest *National Geographic.*

But as an adult firmly planted in the Twin Cities, I've come to realize that nature is something more than photographs of cheetahs chasing gazelles. Nature is a joyful part of my daily life that allows me to experience the passing of time in a way I'd never imagined possible.

On weekend mornings in the winter I regularly take walks on St. Paul's Summit Avenue. The great old elm, spruce, and birch trees are coated with snow and sway and twinkle in concert with wind and sun. In the early morning quiet, the crunch of my boots on the fresh snow seems amplified as I wonder how many winters these wise trees have been through.

In the spring, I head over to the state capitol and delight in seeing the grass come back to life on my way to the Peace Officers Memorial, where tender bulbs poke their heads from the earth to comfort visiting mourners.

The summer afternoon sun will occasionally invite me to leave my St. Paul office early so I can get to Minneapolis before dark for a walk around Lake of the Isles. Every time I see the lake water sparkling like shards of crystal in the day's last rays, I imagine I can decipher the silent, invisible exchange between light and water. At these moments, a conversation with an out-of-town friend often comes back to me: She swore that the Twin Cities' lakes and rivers make our sky a distinctive blue. On those summer afternoons by Lake of the Isles, I believe she is right.

I mark the progress of fall during my trips over the Interstate Highway 94 bridge near the University of Minnesota. From my car, high above the Mississippi River Valley, I'm treated to a breathtaking array of fall colors: leaves of golden yellow, bright orange, and deep russet red. It seems like no time until I experience the shock of naked tree limbs outstretched to capture the first flakes of winter.

Summit Avenue, the grounds of the state capitol, Lake of the Isles, the Mississippi River Valley—these aren't places likely to be written up in *National Geographic.* Yet they are just a few of the landscapes that infuse my rituals of living in the city with a fulfillment that only the natural world can give.

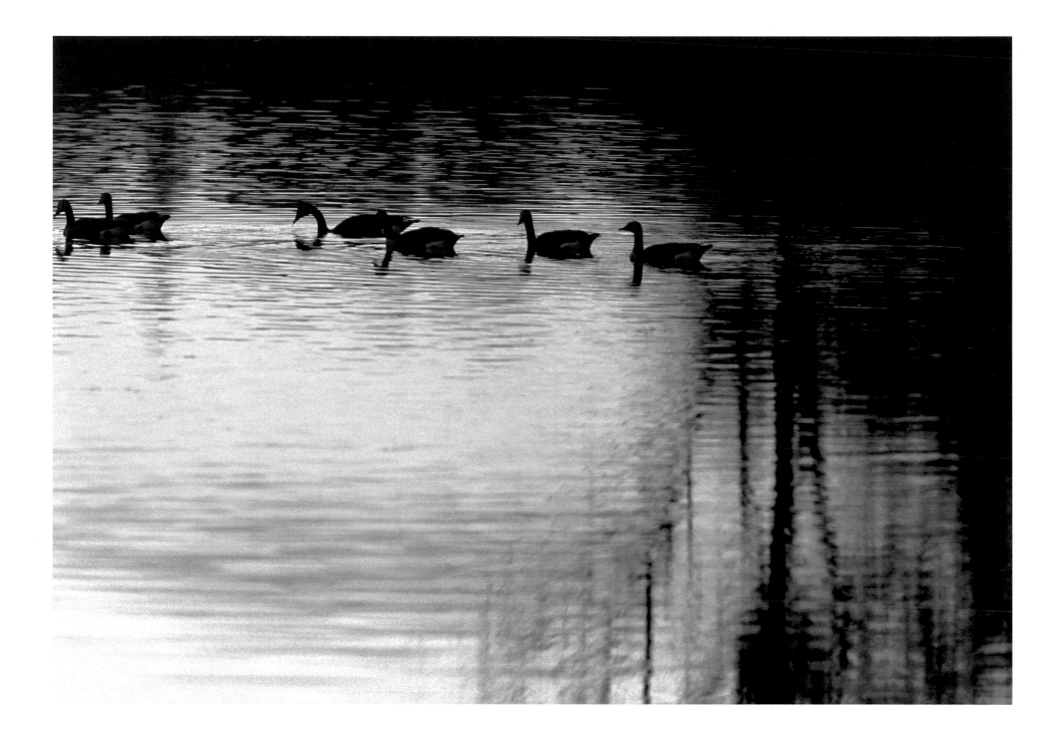

Buffalo Ridge
HOWARD SCHAAP
Edgerton

HOWARD SCHAAP
is an English teacher at Southwest
Minnesota Christian High School, and
he has always enjoyed writing, especially
creative nonfiction and poetry. He devel-
oped a deep relationship with the land-
scape on hunting and fishing trips with
his father, who pointed out the majestic
views of southwest Minnesota, espe-
cially those near Buffalo Ridge. Through
these experiences, he developed a fasci-
nation with the tall-grass-prairie biome.

THE SUNRISE THIS MORNING POURS OVER THE HORIZON.
I half expect the buffalo to come with it, stampeding thunder-
ously, raising dust clouds, their nostrils snorting a double-
barreled mist. They will not come, of course, but their ghosts
are here in the early morning dawn.

It was my dad who gave me this gift, the gift of paying
attention to the landscape on which I live. On Sundays, on
the way to church, as we climbed the hills of the Buffalo
Ridge in our Chevy Citation, he made sure we saw the mag-
nificence of this place. It was the beginning of real worship
in many ways, a simple alerting, directing my eyes and my
heart toward the beauty in the land.

"Look at this bowl, here, the slow curve of the earth, the
hundreds of fields laid out like patchwork."

We would always be on the same hill, in the fall, next to
the Luchtenburg dairy. From that hill we had a clear view
of the final miles of the Buffalo Ridge in the west, the bowl
of countryside dotted by silos, crossed by fields of crisp corn
and rust-colored beans, punctuated by long prairie-grass
ditches.

"Look how clear Blue Mound is from here."

That patchwork of farms sloped gently up to the ridge,
which bent along the entire horizon toward the south, draw-
ing the eye naturally until its sheer drop-off at the quartzite
cliffs of Blue Mound, perhaps twenty-five miles from where
we were standing.

It's a haunting view if you know the legends. The cliffs
at Blue Mound were the site of buffalo stampedes choreo-
graphed by the Dakota. I imagine it to be a huge undertak-
ing: scouring great distances from points like the Luchten-
burg hill; slowly stalking, guiding the herd toward the great
ridge; stampeding them finally over the red rocks cast like
corpses along the Luverne countryside. I see these humped,
frightened creatures suddenly airborne, plummeting to
their deaths. And still, I picture this being done within a tra-
dition of worship, of fear in the face of a drama of life-giving
magnitude.

My father taught me to hunt on this land. Perhaps that's
why this legend of the hunt on the tall grass prairies thrills
me so. We lost our farm in the '80s, our seat in the shadow
of the Buffalo Ridge. But I have not yet lost the greater gifts
he gave me: the gift of thundering hooves across the barren
horizons on a crisp November morning, the gift of the
beauty and ghosts around us, the gift of landscape.

*The author and
his daughter, Sommer*

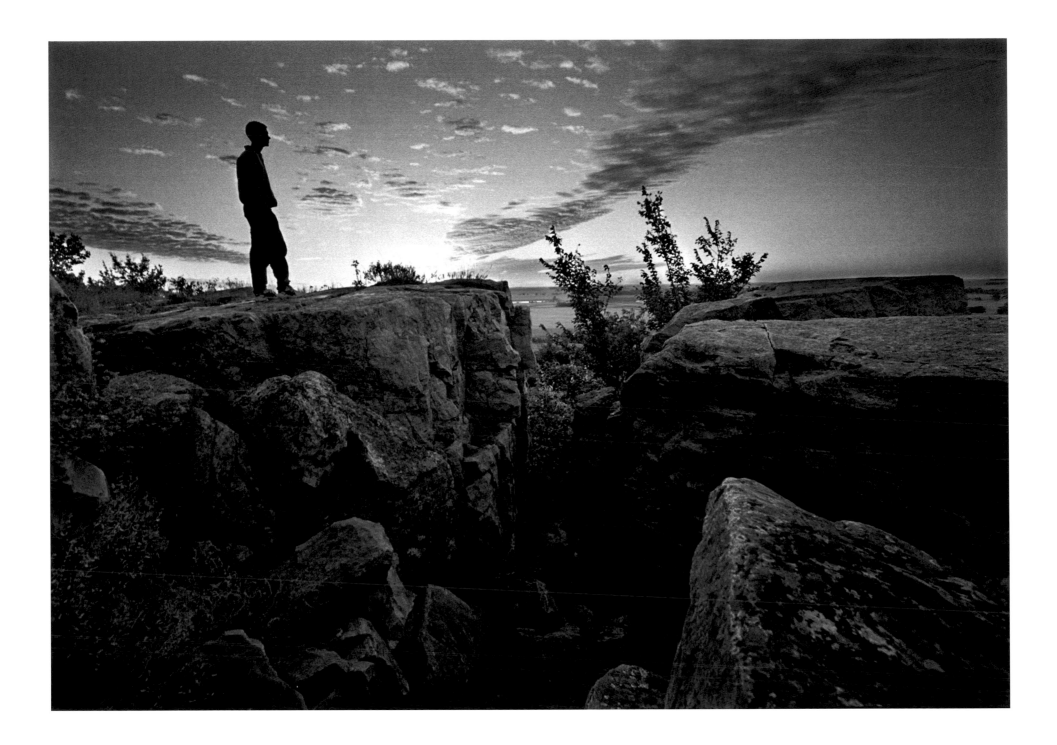

A Remembrance
ROSEMARY RUFFENACH
Minneapolis

ROSEMARY RUFFENACH
has worked as an educator, a policy
analyst, a watercolorist, and a writer.
She was raised in suburban Robbins-
dale adjacent to Victory Memorial
Parkway, and she learned early that
she could find solace under its digni-
fied elms. Later, living on the parkway
with her young family, she watched
the elms wither and be replaced and
taught her children to share in the
cycles and spirit of the Drive. She
describes nature's draw: "When
surrounded by verdant green, crisp
ochres, and blue-purples of lake and
sky, I am as close to the divine as
a human can be."

"THE DRIVE" is North Side lingo for a northwesterly section of the Grand Rounds parkway that belts the city of Minneapolis. As envisioned by landscape architect Horace Cleveland in the 1870s, the Rounds was to be a fifty-mile green sash that linked the Mississippi River with the city's parks and lakes. But I was a grown-up before I learned that.

For me, the parkway was first like a green river. By myself I had no way across it, yet on its other side was my only playmate. I would stare across the divide, hoping for a glimpse of Henry. But since he rarely appeared, I created Kangles, a brave friend resembling Little Orphan Annie, who would forge her way across and play with me.

When I was six, we moved to a more westerly section of the Drive. It was about then that I noticed the black iron crosses. Except a few weren't crosses. They were funny stars, which I carefully counted on my way home from school.

When I was allowed to range further, I'd ride my bike to visit Abraham Lincoln, who, seated in a ring of spruce, stared thoughtfully across the roadway at the pink marble walls bearing the names of the World War I dead. What did he think in his little quiet grove? I'd climb up on his knee for a moment, enjoy the view, and then scramble down, hoping no one had seen me talking to a statue.

During my lonely teen years, the Drive became my friend in solace. As I paced her length, I found companionship. I especially loved her in bleak November, when she looked just as I felt: bare-branched elms swinging their arms in woe, the ground turned a hard ochre. Then her sunny-day friends had fled to warm dining rooms, and I had her all to myself.

When I returned to the Drive as an adult, it was with my own family. We had toured a hundred homes for sale, but none called like the big white stucco sitting comfortably on her east bank. Each of my children, from baby stroller and sled, learned her moods. And after every Memorial Day weekend, I would find hidden in a child's room one of the little U.S. flags that had been placed in remembrance on the crosses and stars—a gift from the Drive.

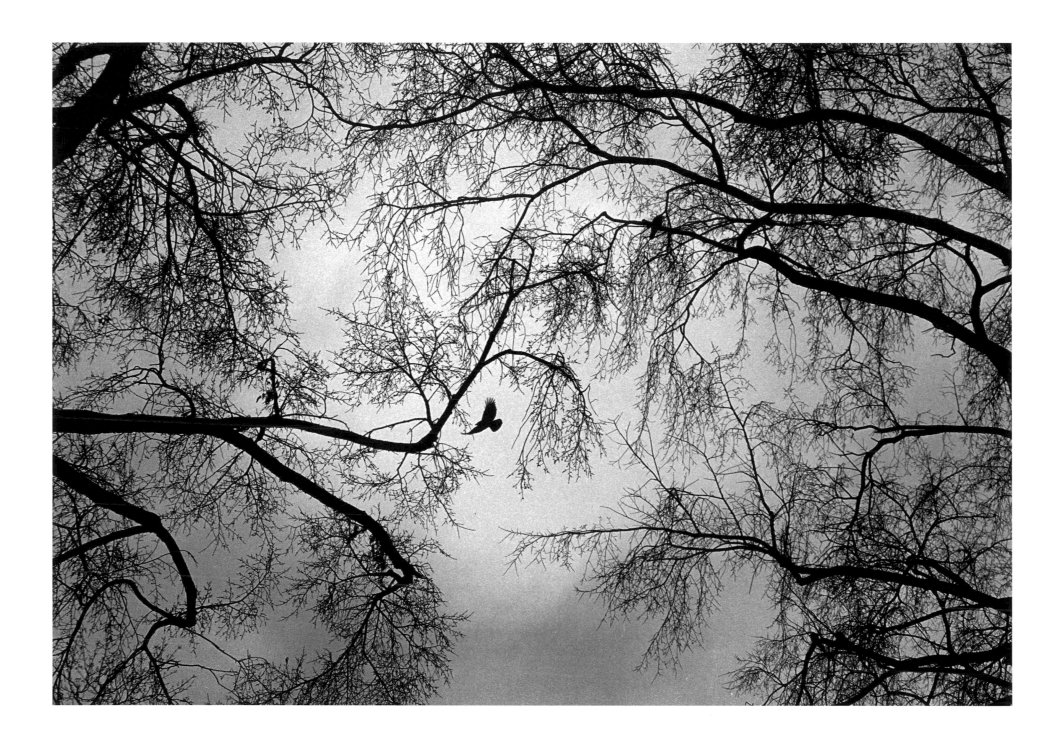

Sacred Ground
REUBEN DUNDER
Isanti County

REUBEN DUNDER
now lives in New Hope, but he grew
up in Princeton, Lindstrom, and rural
Isanti County at Oxlip. He recalls be-
ing surrounded but underwhelmed by
nature and wishes that he had thought
to respect it more. He served in the
U.S. Navy during World War II and
then pursued a career in the plumbing
and heating business. He has always
enjoyed writing, from letters to
stories, both semi-true and fictional.

I GREW UP IN A FARMING COMMUNITY about forty miles
north of Minneapolis in Isanti County. Each fall and winter
I tramped through the nearby woods with my trusty
.22-caliber single-shot.

My favorite haunt was a neighboring farm where the
pasture was under oak trees and at least part of the open
land was planted with corn every year. That made it attrac-
tive to squirrels because of the acorns and corn and to me
because the cows kept the underbrush down, improving vis-
ibility. The adjacent land was overgrown, so we could get
close to a pheasant or partridge or rabbit. Sometimes I just
sat on a stump, waited and watched and took it all in.

In the '30s, during the Great Depression, when I could

scrape up the money, .22 shells were seventeen cents per
box. This was the best part of life as far as I was concerned,
and the family was glad to see the meat for the table if I
dressed it out.

In the past sixty years things have changed. No cows in
the pasture, new houses scattered all around. Slough holes,
which always held water most of the summer, are dried up.

As I drive past, seeing visions of that thirteen-year-old
hunter, walking, stalking, and crawling, I wonder if the peo-
ple in the new houses realize what sacred ground they have
built on. And I measure my small visions against those
of the Native Americans, who look out at our cities, roads,
bridges, and dams and certainly must cry.

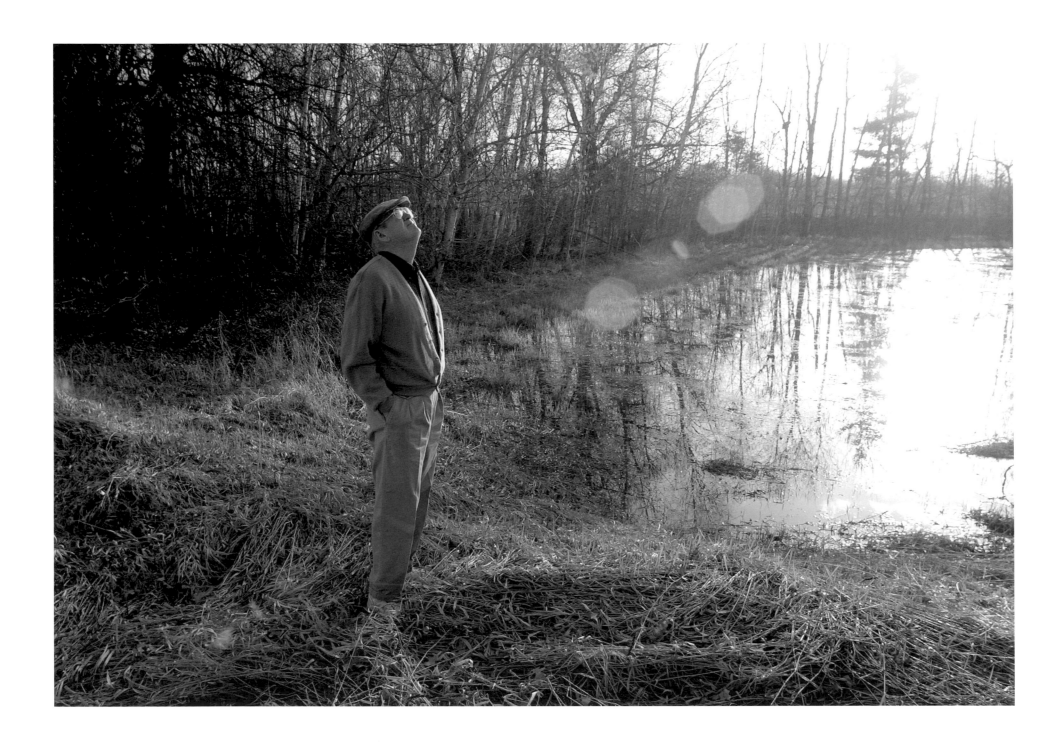

Deer Stand
ANDY ROTCHADL
Mankato

ANDY ROTCHADL
attends Loyola High School in Mankato,
where he pursues interests in music,
public speaking, theater, and sports. This
essay is his first to be published, and he
is inspired to continue with his writing.
He is grateful to his father for introducing
him to hunting: "I develop a greater appre-
ciation for the natural world when I am
able to sit with nature all around me."

WHEN I STARTED OUT TOWARD MY STAND, I noticed how damp and soft the ground was from the morning dew. Fallen leaves crunched under my feet. It was very peaceful and quiet. It was then that I knew this was going to be a fun weekend.

As I sat down, it was very hard to see through the woods. Although I couldn't see, I did hear some rustling in the leaves. A pair of squirrels were fighting and making a lot of noise. They didn't stop chattering the whole weekend. Off in the distance I heard a group of wild turkeys, very faint and quiet. There was a river of grass in front of me as thick as the slough next to it and, on the other side of a fence, a corn-field that hasn't had a crop for a long time. Holding my gun, my fingers ice cold, I looked for deer. My fingers suffered for no reason; I never fired my gun.

I remember being introduced to this stand. My dad was showing me all the deer stands in our back yard. I particu-larly liked this one because of the deep grass. I thought the deer would like to lie in it. They obviously didn't want to this weekend. I will always remember this as my first deer stand. Even if I didn't get a deer, it was still fun. The trees, the long grass, the cornfield, even the squirrels. They were all part of my first hunting trip and all part of my stand.

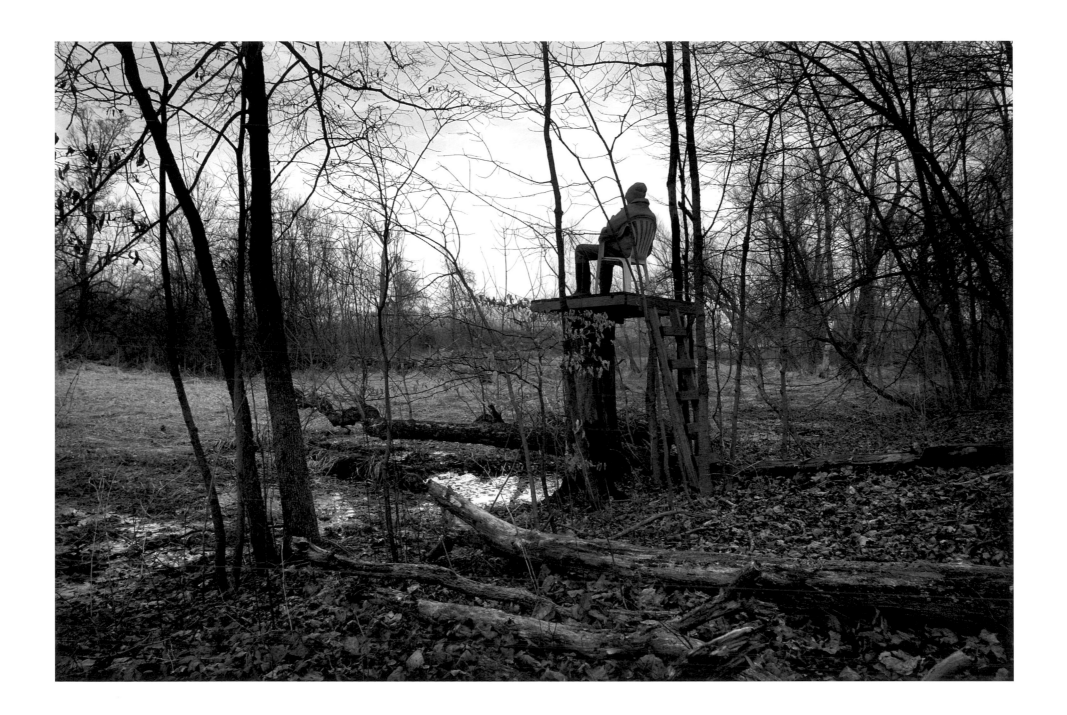

Near Winter
AL PAULSON
Cambridge

AL PAULSON
grew up in the Chicago area and then
spent fifteen years in Los Angeles.
He now lives in Minneapolis, where
he works as a freelance writer and
factotum. His work has been pub-
lished in *BAM Magazine, Rip Maga-
zine,* the *Cambridge Star,* and the *Utne
Reader.* He claims a lifelong and in-
stinctual love of nature and remem-
bers with particular fondness family
visits to his grandparents' farm near
Cambridge, which provided refresh-
ing adventures for a child of the city.

SNOW, LIKE THE BREATH OF A SLEEPY GOD, lays hands on the woods and fields. Falling as tranquil manna, it soothes the starving gray landscape like an invasion of feathers— softly floating into the arms of the earth. Now is the perfect time for a walk.

Evening arrives in soft arrangements as my feet crunch down a gravel road powdered by the early gasps of winter. Unnatural colors paint the horizon, deepen by the moment, then settle into rich natural hues of night. Naked trees claw at a navy sky with skeletal fingers as I turn a corner and head down a deserted lane into a white path of silence.

As one who has spent the past fifteen years in Southern California, I can truly appreciate the subtle mood changes of the seasons. Each has its own personality in the form of scent, temperature, and appearance. I feel so sorry for those who cannot perceive and relish the unique eras of beauty that compose a full year's character.

I came here years ago, as a child of big-city life, and loved the natural wildness of a world void of human presence. But things have changed. An onslaught of suburban develop- ment has made footings into what once was a small farming community in central Minnesota.

Everywhere I look on a winter night, I can see lights. The cult of convenience has permanently scarred the land with mini-malls, super-stores and more cancers of commerce. It's sad, but the quest for large lawns and cheap housing has spread the epidemic of suburban sprawl. As a veteran of Los Angeles, I can attest firsthand to the tragedy of unchecked urban growth and expansion. It hurts to see plains, prairies, and forests subdivided, subverted, and sold, as humans con- quer the expanses of this once-vast continent.

But tonight is not a night for fear and regret; it is a time to savor the arrival of winter's subtle charms. I turn off the road and wander into a dark stand of trees. The air has a brittle aroma and a moist aftertaste. Nearby sounds are muf- fled while distant sounds are resonant and crisp. Tonight is a night to get lost in one's own senses and let the voice of the land take you.

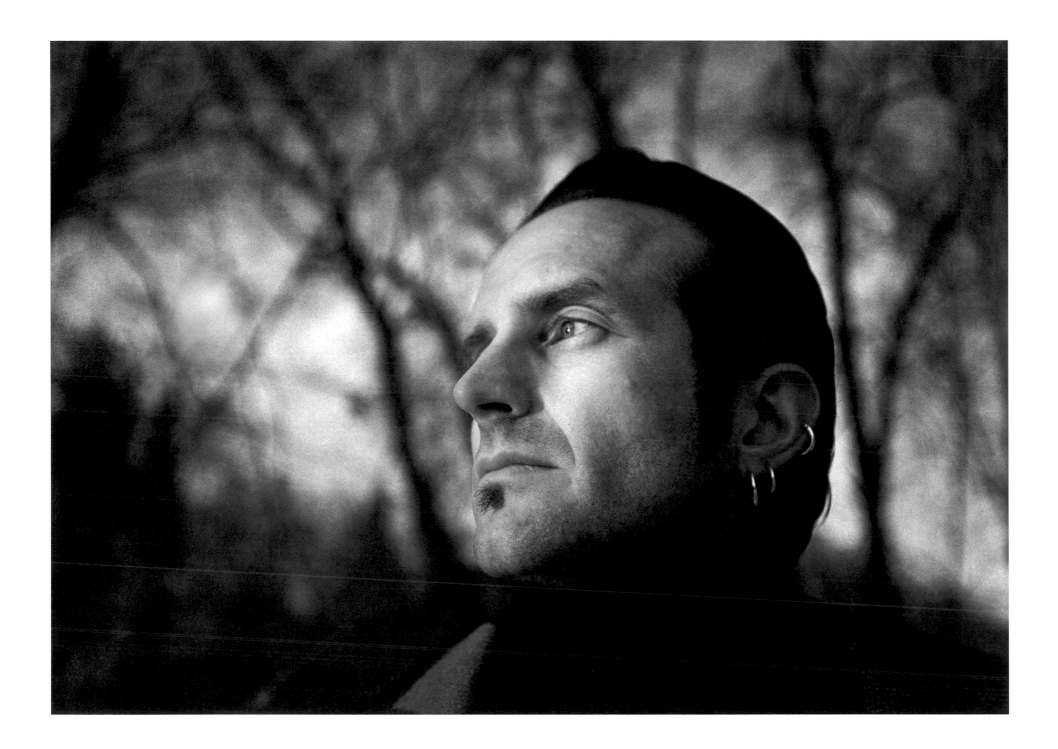

Rocks and Roses
KATHARINE JOHNSON
Chisholm

KATHARINE JOHNSON
writes children's stories, memoir, and
nonfiction. Her stories have appeared in
Ladybug magazine and in the Bemidji
State University publication *Dust and Fire*,
from which she earned the Jonis Agee
Fiction Award. She grew up in the country,
where her parents taught her to value and
enjoy the outdoors. She has also studied
ecology and realizes the importance
of taking action to protect what she
appreciates. She considers the best use
of her time to be that spent out-of-doors.

MY CHILDHOOD FARM is near a spot where three watersheds join: the Mississippi River, the St. Lawrence River, and Hudson Bay. My mother used to say that these exotic-sounding places were the reason our well ran dry. All waters flowed away from that farm, high on a hill, north of Chisholm.

To catch some of the water before it flowed to the Hudson Bay, my mother and I set barrels under the eave line of the house. We used the captured rainwater for washing clothes, for luxuriously soft shampoos, and for the sauna.

In addition to a scarcity of water, our farm had little topsoil to cover the glacial rubble of sand, gravel, and clay. The thin soil barely produced a field of timothy for wintering two cows.

Despite the hardness of the earth, delicate violets pushed through the clay. Wild roses bloomed next to granite boulders. Rough rocks shaded pink pyrolas. Trailing arbutus hugged the rocky ground.

The last glacier dumped boulders as small as fattened pigs or as big as sleeping elephants. Boulders were scattered in the pasture, in the chicken yard—everywhere.

Hardscrabble as this farm was, it was my childhood wonderland.

The rocks and boulders became fantasy castles and circus arenas. I sat on sun-warmed thrones to watch clouds metamorphose from wicked giant heads to wisps of cotton candy. I climbed them to reach wild plums and cherries. I served tea to Roy Rogers and Trigger from a rock next to wild roses.

My brothers and I sought supple birches to bend and swing on. We followed the tap, tap, tap of woodpeckers, hoping to find hollow nests. We picked dessert from fields of strawberries, patches of blueberries, and tangles of raspberries. We hid behind boulders, climbed tall spruce trees, and crawled into thickets of hazel brush.

After a steamy Saturday-night sauna, we lay on the cooling boulders to watch the northern lights shimmer like green and silver celestial curtains. Coyote songs drifted in the still air. Mosquito bites brought us back to the hard rocks of reality.

Mississippi, St. Lawrence, and Hudson are no longer exotic-sounding places to me. It is this childhood farm of rocks and wild roses that fills the well of my imagination.

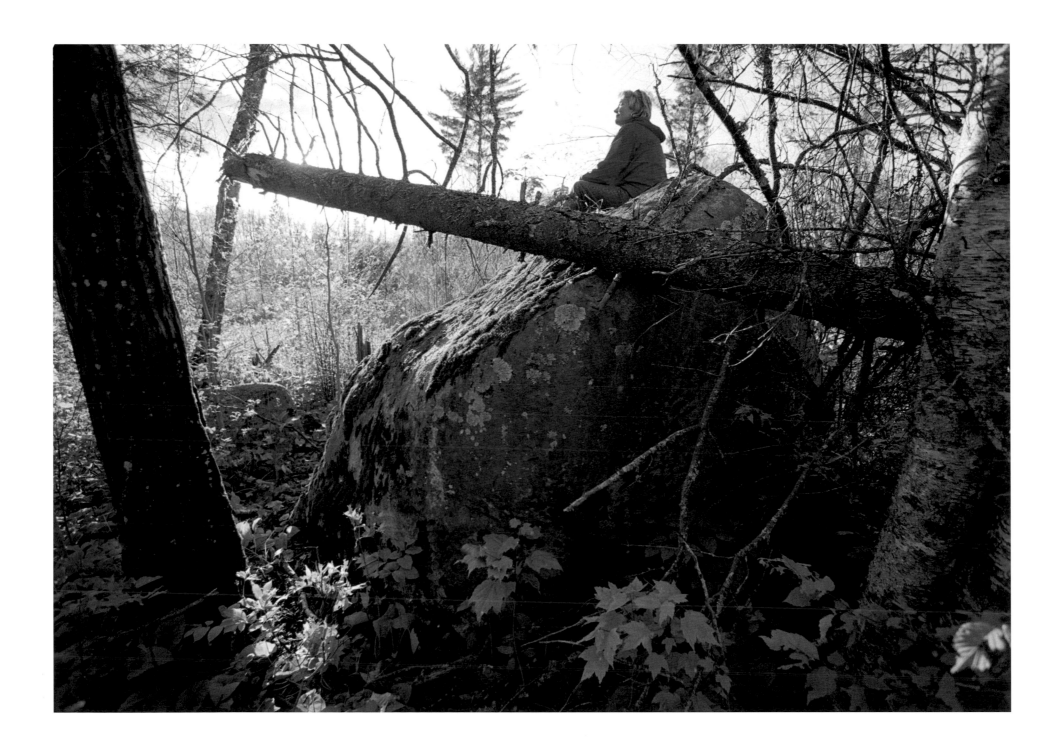

Riverview Cemetery
JOAN P. PASIUK
St. Paul

JOAN P. PASIUK
works as an administrator at the
University of Minnesota. She has
published several personal essays and
a book, *Adventures in Careering: A Twin
Cities Field Guide.* Many of the places
she has come to love are at the edge of
or in the midst of development. Grow-
ing up in Illinois, she swam at beaches
recovered from coal strip mines, picked
bittersweet along the towpath of the
DuPage River, and chopped firewood
on her uncle's farm just down the road
from a nuclear power plant. Joan be-
lieves that urban green spaces are as
important as wilderness areas and that
most of us will encounter the mysteries
of the universe from a park bench or
walking path in the middle of the city.

THE GRAY AUTUMN CHILL casts a somber shadow on the city. I walk through rows of granite markers at Riverview Cemetery, a grassy knoll on the river bluff. Nestled in a modest neighborhood, it overlooks a brawny cityscape of oil tanks and industrial smokestacks. Traffic from the nearby interstate drones an urban anthem.

Despite the distractions, it is a solemn place. I am alone except for an old couple ambling toward their car, leaning into each other like two leaves at the end of a brittle twig.

My ancestors are buried far away, so I visit this cemetery, paying tribute to forebears with whom my only link is hav-ing called this city home. I feel intrusive at first. When epi-taphs whisper in the wind—"*la nina mas preciosa,*" "angels watch her sleep," "*wir sehen uns wieder*"—I draw closer.

A small marker next to the road is jagged, rustic, honed by amateur hands.

> Seneca
> Princess of Chief White Cloud
> Ahwahneitta Baker
> B. 1875 D. 1930

A pink silk rose, yet unfaded, lies at the base of the roughly chiseled letters. A recent visitor paid respects at this old grave?

I used to think cemeteries were maudlin, frivolous, old-fashioned. We could better remember loved ones in private ways, with a picture on the bureau or a memorial tree in the garden. But here, personal grief becomes community witness: bunnies on a shiny whirl-a-gig dance an endless jig for a four-year-old at rest; pumpkins, a lit candle in a tall glass jar, and a pepper plant with miniature red shards mark the grave of a beloved father; a khaki cap is impaled with whiskered fishing lures; turquoise rosaries and a Mexican flag drape a plastic foam cross; Mickey Mouse, in red-footed pajamas, and Minnie, in a gold lamé ballet dress, offer un-failing companionship to a small soul nearby.

Cemeteries are more than burial grounds. They are tes-timony to the value of life and the resiliency of this place. Hundreds of thousands of teachers, bridge builders, grand-mothers, factory workers, and unheralded contributors to the prosperity and civility of our community are gone from our midst. Yet we thrive. In this cemetery with the river view, I feel the flow. It was their city, now mine, next a place for St. Paulites yet to come.

> *Hija querida*
> Beloved daughter
> *Recuerdo de tus padres*
> In your memory, from your parents
> *Hermano y familiare*
> Brother and family
> *Descansa en paz*
> Rest in peace

Gone but not forgotten.

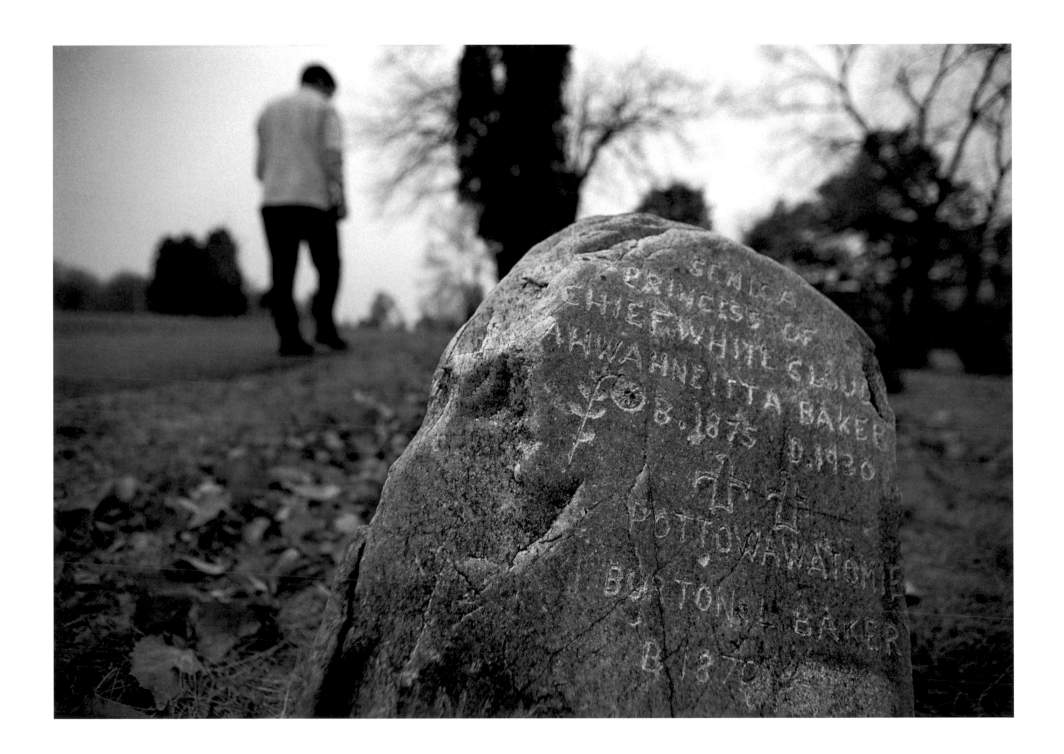

The West Bank
GIL QUAAL
Itasca County

GIL QUAAL
remembers being introduced to nature when he was three: "My father, anticipating danger, placed me on a mossy log and proceeded to kill a snake. Out of its writhing body a score of colorless young escaped. What an initiation!" Other early curiosities that strengthened his connection with nature include inchworms, birds in flight, toad warts, the smell of pine pitch, and the bright colors of woodland berries. He writes to share his experiences in nature with others, knowing that from among our numbers will emerge the "sensors" that help to keep our small world intact.

I AM AN OLD MAN who no longer counts his years. Instead, I measure life's passage in seasons. Calendar years are linear, while my life is a circle. Calendar time concerns itself with birthdays and obituaries; my time focuses on the first morel and the dance of the mayflies.

How can one measure life as a circle? I do it through natural activities in which I collect maple sap, pick fiddleheads, gather raspberries, hunt ducks, and fish through the ice. These sequelae each occupy a segment of my circular year.

I visit many places in the course of my forays, but none is so special as the west bank of the Mississippi. It yields bountiful harvests, and not all of them are food. A lap starts where the big river spills out of Little Winnie and ends at U.S. 2 near Ball Club.

Afoot, one has access not only to nut and berry, but also to those hidden cynosures that paint indelible pictures on the mind. In my collection are carousels of pink moccasins, dark green, deep-piled lycopodium carpets, and bright-helmeted armies of emerging mushrooms—all enshrined within a timeless frame.

But these are just vignettes painted within a much broader canvas. The Mississippi's west bank is more than a landform covered with vegetation. It is communal life expressed in a language more esoteric than Sanskrit. I have learned some of its alphabet, and although the words elude me, one message always comes through and it is this: There is a cyclic unity in all things.

Once, in a grove overlooking the river, I was suddenly immersed in a tidal wave of birds. Come! Come! they chanted, until I succumbed to the same spirit that moved their mass. My consciousness became airborne, and it was difficult to call it back. Experiences like this enable me to see that there are linkages among species that transcend common understandings.

One needs places like the west bank in which to regenerate, places that enable us to understand that although we grow older, our lives don't really end. We too are part of the cycle.

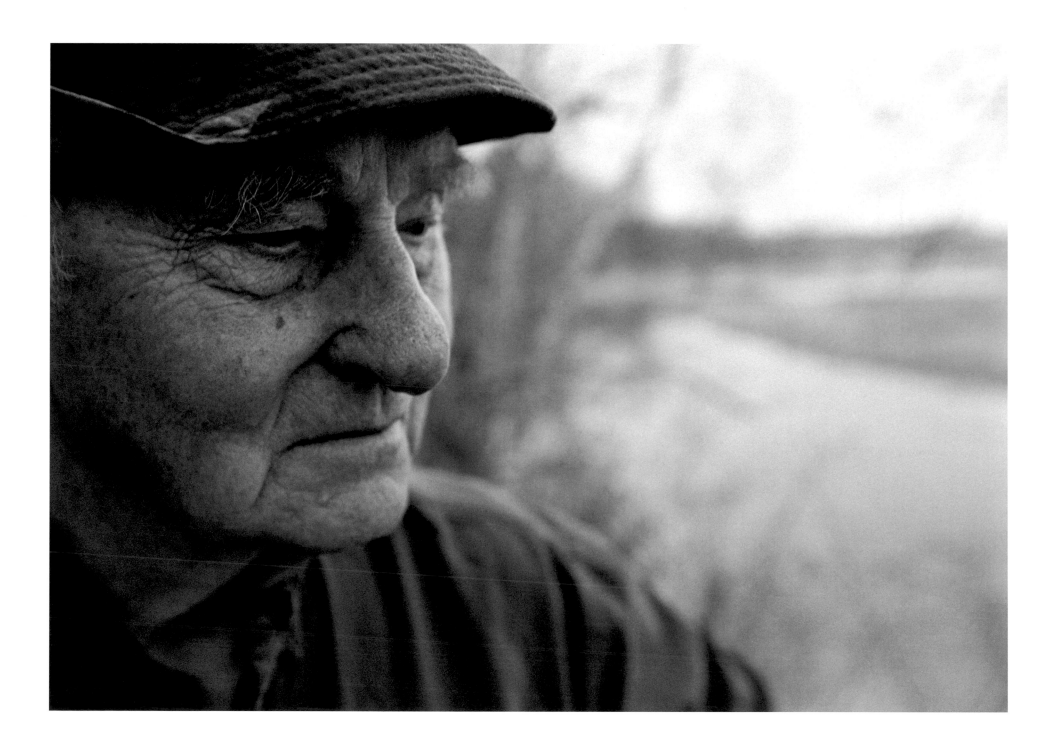

Locations Described in the Essays

WASKISH
Carla Hagen

MOORHEAD
Mark Vinz

BECKER COUNTY
Judy Henderson

BEMIDJI
Michael Forbes
Eleva Potter

PELICAN RAPIDS
Joan Jarvis Ellison

ITASCA COUNTY
Gil Quaal

SIDE LAKE
Jan Petrovich

ST. LOUIS COUNTY
Peter Pierson

CHISHOLM
Katharine Johnson

CLARISSA
Kayleen Larson

CHAPEL LAKE
Becca Brin Manlove

MELROSE
Mary Woodford

CUYUNA IRON RANGE
Jeri Niedenfuer

AITKIN
Lewann Sotnak

LAC QUI PARLE
Lynn Lokken

ST. WENDEL TOWNSHIP
Larry Schug

HAYLAND TOWNSHIP
Karen Schlenker

DULUTH
Lisa Brecht
Jean Sramek

TWO HARBORS
Forrest Johnson

GRAND PORTAGE
Joanne Hart

MINNEOTA
Bill Holm

CAMBRIDGE
Al Paulson

ISANTI COUNTY
Reuben Dunder

BUFFALO RIDGE
Howard Schaap

ST. MICHAEL
Jessyca Duerr

ANOKA COUNTY
Don Kaddatz

MAPLE GROVE
Lacy Belden

MEDINA
Elizabeth Weir

MINNETONKA
Molly Dworsky
Mai Nguyen Haselman

HOPKINS
Patricia Isaak

ST. LOUIS PARK
Lora Polack Oberle

GOLDEN VALLEY
Jane L. Toleno

MINNEAPOLIS
Carol Dines
John Holmquist
Margaret Miles
Elspeth Kate Ronnander
Rosemary Ruffenach

MINNEAPOLIS–ST. PAUL
Greta Cunningham

RICHFIELD
Gustave Axelson

MISSISSIPPI RIVER
Thuy Nguyen

ST. PAUL
Yujung Hu
Joan P. Pasiuk
Tom Patterson

SHAKOPEE
Catherine Doege

MONTGOMERY
Lawrence Morgan

MANKATO
Micaela Brown
Brian Cornelius
Andy Rotchadl

ALTON TOWNSHIP
Newell Searle

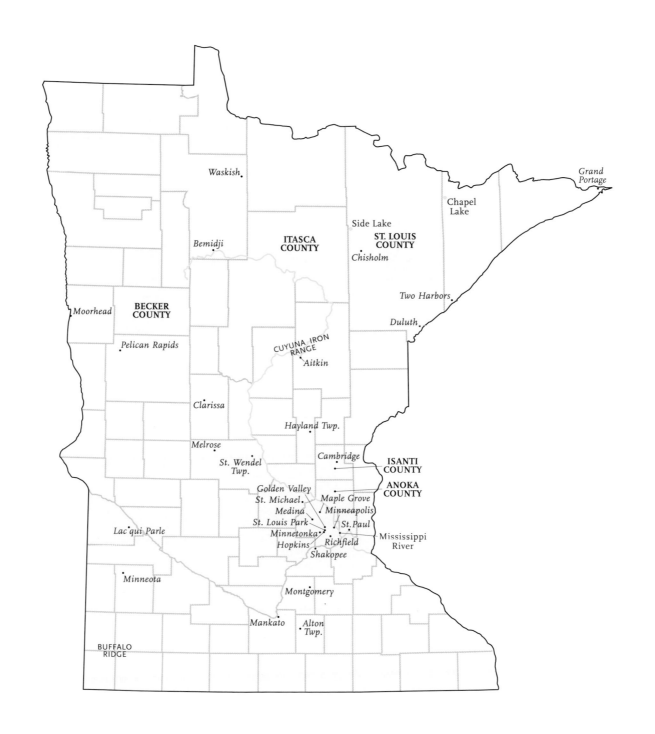

Waskish

Chapel
Lake

Grand
Portage

Side Lake

ITASCA
COUNTY

ST. LOUIS
COUNTY

Bemidji

Chisholm

Two Harbors

Moorhead

BECKER
COUNTY

Duluth

Pelican Rapids

CUYUNA IRON
RANGE

Aitkin

Clarissa

Hayland Twp.

Melrose

Cambridge

ISANTI
COUNTY

St. Wendel
Twp.

ANOKA
COUNTY

Golden Valley
St. Michael
Medina
St. Louis Park
Minnetonka
Hopkins

Maple Grove
Minneapolis

St. Paul
Richfield
Shakopee

Mississippi
River

Lac qui Parle

Minneota

Montgomery

Mankato

Alton
Twp.

BUFFALO
RIDGE

Index to Authors